# APERTURE

## OUR TOWN

3 FUNKY TOWN
By David Byrne

4 LIKE SILK
By Marianne Wiggins

31 WHOSE TOWN?
Questioning Community and
Identity
By Michele Wallace

40 APPALACHIA:
The Other Side of the Mountain
Photographs and text by
Shelby Lee Adams

44 THE FRUITED PLAIN
By Nan Richardson

56 HOME
By Gary Indiana

64 S.O.P.
By Richard Ford

72 PEOPLE AND IDEAS
Review of "Open Spain/España
Abierta," by Judith Russi Kirshner
Review of *Airports*, photographs by
Peter Fischli and David Weiss,
by John Waters

76 CONTRIBUTORS' NOTES
AND CREDITS

Photographs by Shelby Lee Adams, Jules Allen,
Robert Amberg, Amy Arbus, S.A. Backman, Ken
Botto, Peter Brown, Lynn Butler, David Byrne,
Sophie Calle, Jack Carnell, Gregory Crewdson, Ted
Degener, Philip-Lorca diCorcia, Donna Ferrato,
Stephen Frailey, Jerald Frampton, Gran Fury, Jim
Goldberg, David Graham, Alex Harris, Abigail
Heyman, Ethan Hoffman, David Husom, Jeff
Jacobson, Stuart Klipper, Leon Kuzmanoff, David
Lee, Jerome Liebling, John Leuders-Booth, Andy
Levin, O.Winston Link, Mary Ellen Mark, Charles
Mason, Skeet McAuley, Rhondal McKinney, Susan
Meiselas, Richard Misrach, Patrick Nagatani,
Marilyn Nance, Adrian Piper, Sylvia Plachy, Joseph
Rodriguez, Sheron Rupp, Sandy Skoglund, Clarissa
Sligh, Michael Spano, Joel Sternfeld, Paul Strand,
Nick Waplington, Patrick Zachmann

D1104053

# FUNKY TOWN

By David Byrne

*"Our Town" considers the idea of community in the United States today. With images by over fifty photographers and a diverse group of personal essays, we journey through a multitude of representations and perspectives: small towns and suburbia, replete with shopping centers, main streets, neighbors, and white picket fences; urban communities, as established by a sense of turf and group identity; home and family as community; farm communities and the plight of the farmer; community as expressed through shared interests; and the concept of community or non-community, of "our town" as Anyplace and No Place, U.S.A.*

*We took the liberty of borrowing from Thornton Wilder first our title and then our means of introduction, inviting David Byrne to be our Stage Manager (he kindly accepted). We asked him to look at the photographs while we were preparing this issue of* Aperture, *and then to set the stage for "Our Town."* THE EDITORS

The small towns of North America are a far cry from what they used to be. While cities like New York, Los Angeles, and Miami have been, effectively, third-world capitals for some time, now the thousands of smaller towns also reflect this new national character. The combined impact of our nationally subsidized highway program, the once-mighty auto industry, and the new multicultural mix have changed "our towns" into something strange and wonderful.

Oddly enough, photographers, myself included, have so far side-stepped their duty as society's antennae (a questionable duty, for sure). Rather than confront this new reality, many of us cling to an older, almost nostalgic view of small towns, or the urban small town—the ghetto. Yet the photos in this publication manifest an alienation and anxiety about what has become of these places and where they are headed. A sense of dread pervades the images. Something ugly is going to happen here. Soon. Thornton Wilder has turned into Stephen King.

But maybe it ain't all bad. Maybe much of what has happened, and is happening, is a cause for celebration, not anxiety. I mean, why are we so frightened by the multicultural beast? What's the problem? A potential source of revitalization stares us in the face, even as the country is falling apart. Now, our new makeup may not be the solution to our economic woes—we've dug a pretty deep hole to hope to get out so easily—but it may at least bring back signs of life to the arts and to the spirit.

European-American capitalist trash culture has colonized the world at least as much as the nineteenth-century colonial powers did, but in a different way. Now the colonized have been welcomed back, at minimum wages, and they have proceeded to colonize the colonizers. I'm not sure nations really know what they're doing when they open their doors, ostensibly for cheap labor. What originates as economic exploitation ends up as cultural fair exchange. You can't fuck someone without getting fucked yourself.

So here we have this bubbling richness in the great urban centers rapidly spreading out to every last burg and truck-stop. It's a richness you can taste and smell—in the food, the music, the dance, the image-making, and the poetry. It's a funky culture. It ain't pristine by any means. It's a dirty mix. But purity is an abstract concept anyway. It never really existed. The dish we have is a lot spicier.

The great cities of the world, and what they produced, were the result of such unholy mixtures. Rome, Athens, Venice, Bahia, New Orleans, Budapest, Paris, Istanbul, Accra. On and on. Any contact with the other is an energizing contamination. The confusion and chaos are part of the dynamic. Gene splicing on a global scale.

We are at a critical moment. Our national resources are becoming depleted, our old self-image doesn't exactly jive with what we see in the mirror, our economy is shaky, and our status among nations is questionable. And yet we hold the seeds of cultural rebirth and rejuvenation . . . if we are flexible and cool enough to accept a new definition of what we are. We can go down with the ship, proudly saluting the flag and quoting the pledge of allegiance, or we can get on the tramp steamer bound for who knows where.

Our situation, I think, is unique. Previously, this fission flowed from urban centers; now, thanks in part to the automobile, the whole country is infected. Half a continent! Every little town and village. Dick and Jane are scared outta their skulls. Go with the flow, kids.

In a way, these photos are of a nation on the brink. A fond, or angry, goodbye to a dream that never manifested in reality. A myriad of ghettoized cultures about to confront one another. Pictures of a chemical reaction about to take place. All the right elements are here, but there's no precedent for the new polymer they'll create. It's a new primordial soup. A funky ooze. Good luck to us all, amigos.

## I mean, why are we so frightened by the multicultural beast?

# LIKE SILK

By Marianne Wiggins

*"Mama, do you know what I love most in the world—
do you?—Money."* REBECCA GIBBS, *Our Town*, Act I

Although, in an allegorical sense, I've been an actor on one stage or another for most of my remembered life, the only literal performance in a written play I've ever given was as Emily Webb in *Our Town*, when I was a senior in high school in 1964 in a rural outpost of Lancaster County, Pee-ay. My school was in a town (a village, really) called Neffsville, the ethos and geography of which are pretty much entirely conjured by its name: there was a founding family

> *The Mason-Dixon was a shadow line,*
> *for me. Most people aren't aware of*
> *its existence. But for those who are,*
> *it is a cast of mind, the line*
> *that shapes a Southern character.*

there called Neff; there was a post office, a rescue squad, and a convenience store. There was a stoplight at its single intersection, owing to the school-bus traffic. The school, modern, with a natatorium and all, was bordered by Neff's cornfields. The people who lived thereabouts differed not a lot from the people who resided (and still do, in that imaginary realm) in a place called Grover's Corners.

I loved pretending I was Emily at that age; I remember that, at sixteen, I admired everything about that play. But in the intervening years, I've spent a lot of time outside the United States, all of it outside Pennsylvania, far away from Neffsville.

And I'd never re-read *Our Town*.

I was reading Kawabata, Mahfouz, and Garcia-Marquez: I was writing, trying to create a Voice that was (and is, theatrically) my own.

And here I have to say that I'm not prone to nightmares.

Dreams, a thousand—nightmares, only two or three; among them, the old Actor's. You've had one, I'm sure—the classic Actor's Nightmare. You're called upon to act a role you can't remember. I've been called upon, nightmarishly, to act the part of Emily in *Our*

Jack Carnell, *Ambler, Pennsylvania, 1979*

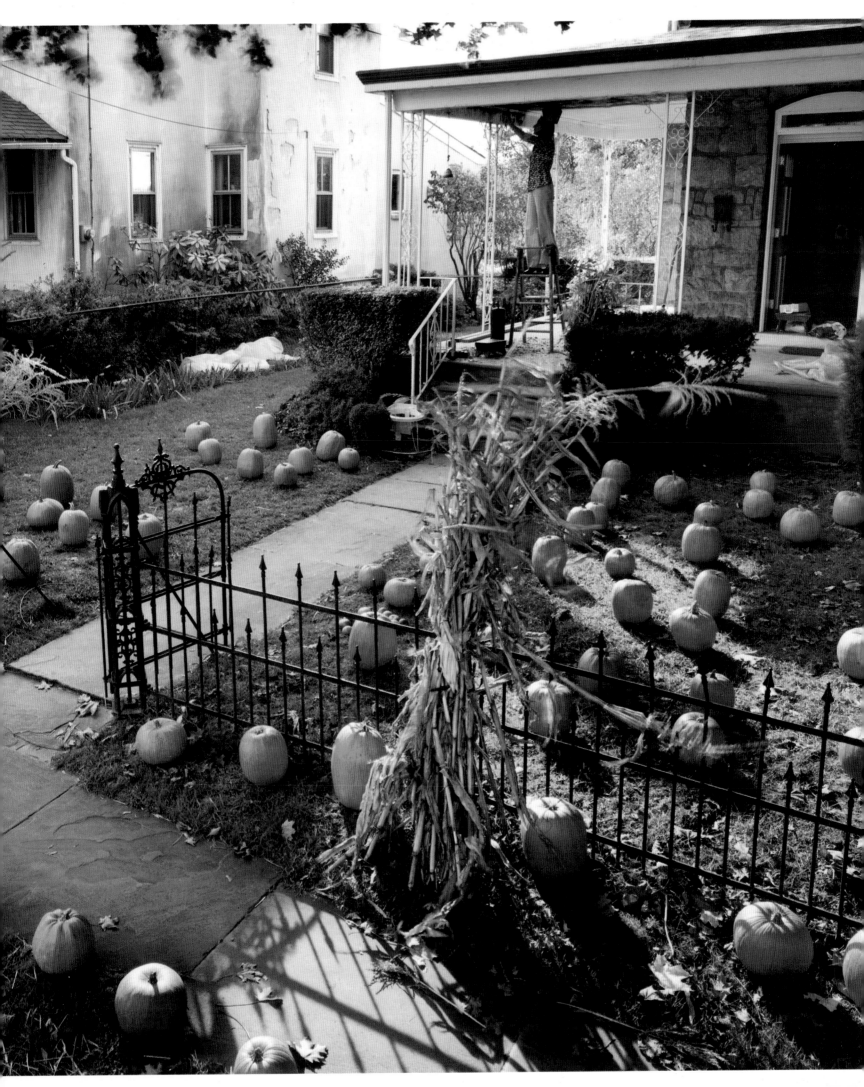

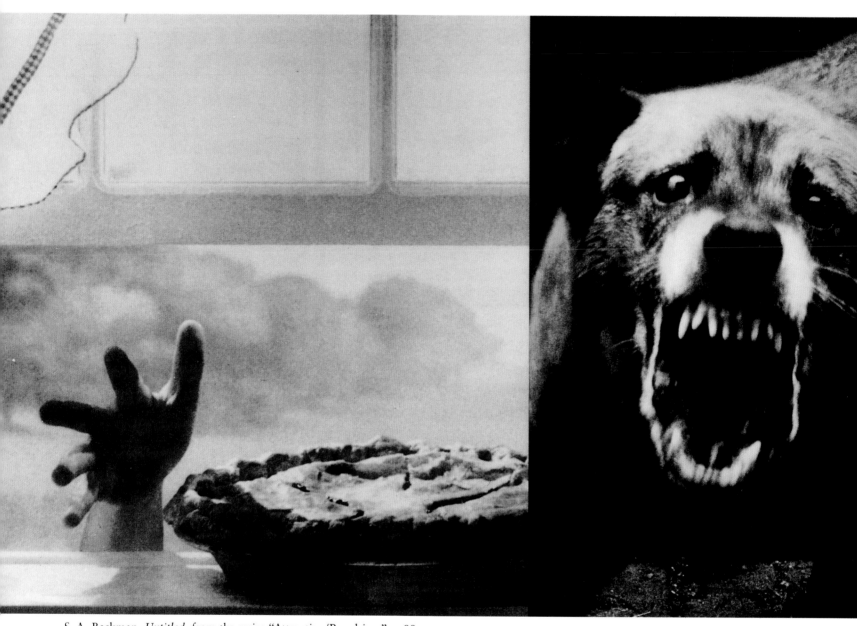

S. A. Backman, *Untitled*, from the series "Attraction/Repulsion," 1988–1991

Hopewell had never been that sort of ideal Southern

town with kitchen gardens and white picket fences.

*Town*, and I can't remember what the play's about, nor any of the lines. Heart pounding, lost and dumbfucked, I have woken in far places, thinking, *what is this? where am I? what am I supposed to say?*

I had two towns to call my home-one, growing up: my father's (Lancaster, Pennsylvania: The *North*) and my mother's, well below the Mason-Dixon line.

*Lines* seem to have been drawn on me, on my imagination, early on: spoken lines and written lines and artificially constructed ones.

The Mason-Dixon line, for instance: north of it you're one thing, south of it you are another. The Mason-Dixon was a shadow line, for me. Most people aren't aware of its existence. But for those who are, it is a cast of mind, the line that shapes a Southern character.

I left my hometown in the North when I was seventeen years old with no intention of returning. I think of it, of Lancaster, with no emotion, and I've never placed a narrative inside its county line. I do not dream of it. It doesn't give me nightmares. The town that I remember, though, the town that I return to, that I write of fre-

> *Perhaps it is because it is a place so ruined and despoiled that I am fascinated by it in my middle-age: ruins are, let's face it, mankind's lasting form of architecture.*

quently, as if hoping someday that I will get it right, is the town across that shadow line, my home-away-from-hometown, where my mother's family was: Hopewell, in Virginia.

What I remember first about it is that, as a child, I hated being there. It smelled. Most towns, most places, do not gain a reputation by aroma; some do, like Secaucus, New Jersey (pigs), and Hershey, Pennsylvania (chocolate). Hopewell stank, and still does, of a combination of old diapers and a burning tire dump. Descending toward it from Route 1, down a steep incline, you could always smell the town first before you saw it. Then, if it was day, you'd see a yellow cloud. At night you'd see the fires on the smokestacks. Just before the bridge across the Appomattox River you would see the sign, now gone, which read: WELCOME TO HOPEWELL, CHEMICAL CAPITAL OF THE SOUTH.

Perhaps it is because it is a place so ruined and despoiled that I am fascinated by it in my middle-age: ruins are, let's face it, mankind's lasting form of architecture.

Hopewell is, without a doubt, a form of abject ruin, a sacred site along America's horizon where the deft illusion of a hazard masked as Luck has danced.

What I could not understand even at an age when I had seen the many masks that chance and luck can wear was how my mother's parents—Anthony, from Skopelos, in the Aegean, and Fanny, from

the island Limnos—came from such great distance, bucked by such thin hope, to settle, given the alternatives of New York, Baltimore, or Boston, in this utter armpit of Virginia. My grandfather's sole attempt to explain his emigration to me before he died when I was ten years old was characteristically Greek in its epic potential, equally Greek in translation-of-meaning: *You can't eat bread made from stones.*

To this day, whenever I look at a map of the Aegean, I see those Greek islands as "stones": KRITI, LEFKADA, LIMNOS, SKOPELOS— my grandparents did not arrive here alone. In the Appomattox Cemetery in Hopewell where they're buried, there are different kinds of Greek stones, bearing the names KLONIS, KOKINOS, VLAHOS, MALAMIS, KARAS, MEROS, HALKOS, KARVELIS, MATOPOU-LOU, all born between 1880 and 1898. Only a few of the Greek names on the stones appear in the current telephone book, the descendants having either died in this succeeding century or gone somewhere else to eat their bread. And when I went one Sunday morning this summer to the 11 A.M. liturgy at St. Elpis Orthodox Church on Poythress Street to see if I could find some faces from the past . . . the priest and I were the only people there.

You can't eat answers made of stones, either, I would like to tell my grandfather. Why *Hopewell*? "They came to work in the silk factory," my mother had once told me. I mean: it was fantastical. A *silk factory*? with *silk worms*? at the confluence of the James and Appomattox rivers on the coastal plain of Old Dominion? *Greeks*?

I made an odyssey of Main Street and of Broadway, those two former arteries of Hopewell's economic lifeblood, looking for the shops I'd known where my grandmother would take me for strong coffee and Greek pastries when I came here as a child each summer. Hopewell had never been that sort of ideal Southern town with kitchen gardens and white picket fences that its neighbor, Colonial Williamsburg, Inc.—that Fantasyland of Virginia, that sow's ear passing as a silk purse—pretends to be. Hopewell had always been a place where things got off the boats and onto trains, or off the land, into the dying rivers. A *chemical* capital—chemistry's not static. It's not surprising that Klonis Bros. Market, the grocery store my grandfather had founded, foundered in its second generation. The building's now a gun and ammo depot with a barren lot beside it. And it's not surprising that the Greek, Armenian, and Italian parts of town are gone, or that the blacks of Hopewell are still ghettoized. What's surprising is that everything is gone, all sense of the "exotic," anything that's strange, everything of character has been erased. The cinema is boarded up. In what was once the center of the town there is a parking lot four square blocks large, big enough to hold Hopewell's pathetic sum of annual tourists if they all showed up at once. Across from it, on Main Street, is the Visitor's Center, trying desperately to flog the town's Civil War connection to a history-hungry nation.

This is the only country in the world that's turned the Actor's Nightmare into a national group therapy, an identi-kit for tourists

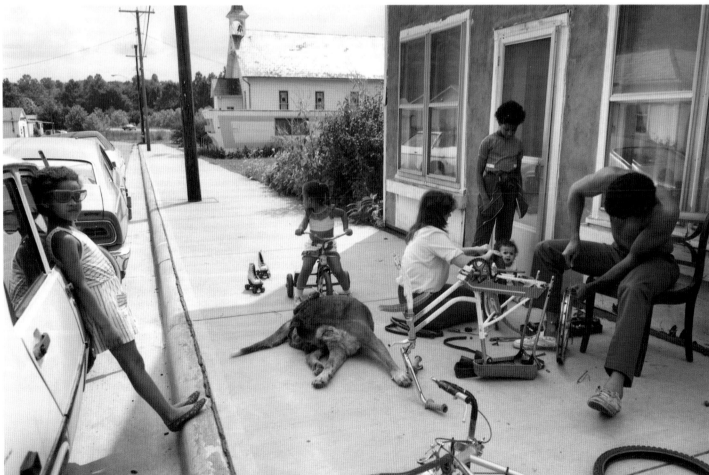

*Top*, David Graham, *Forever Blowing Bubbles, Rabbit Hill near Senator Wash, Imperial Valley, California*, 1985

*Right*, Sheron Rupp, *Rendville, Ohio*, 1985

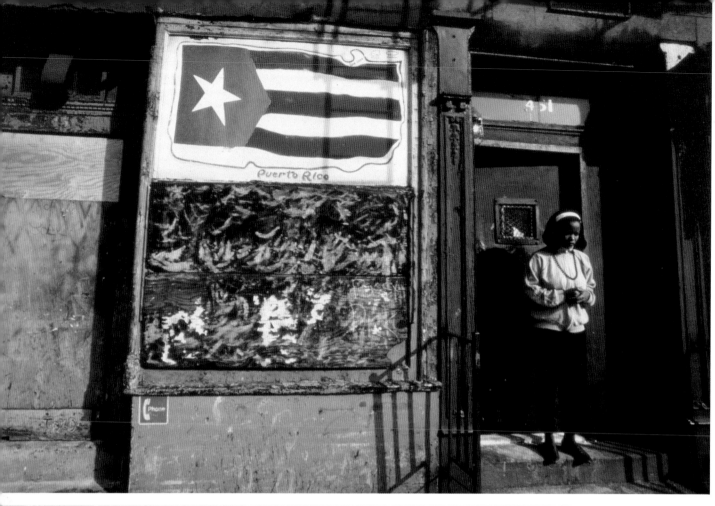

Joseph Rodriguez,
from the series
"Spanish Harlem,"
1985–1989

David Graham,
*Robin,
Feasterville,* 1987

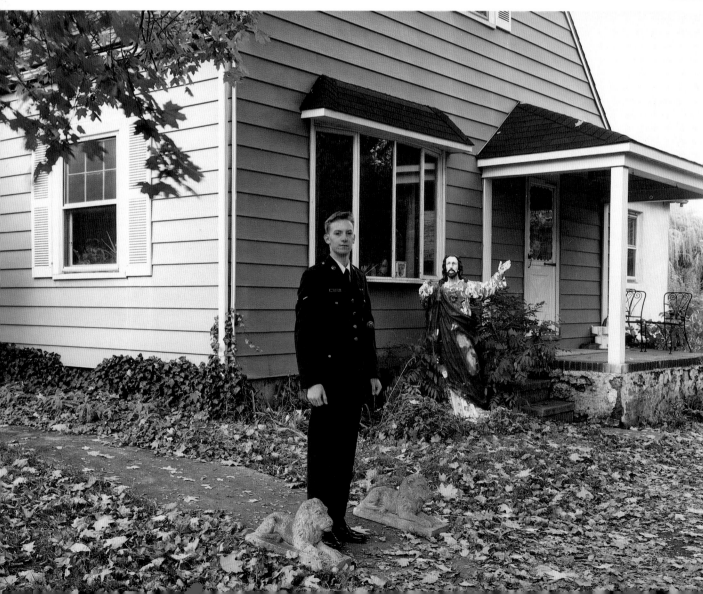

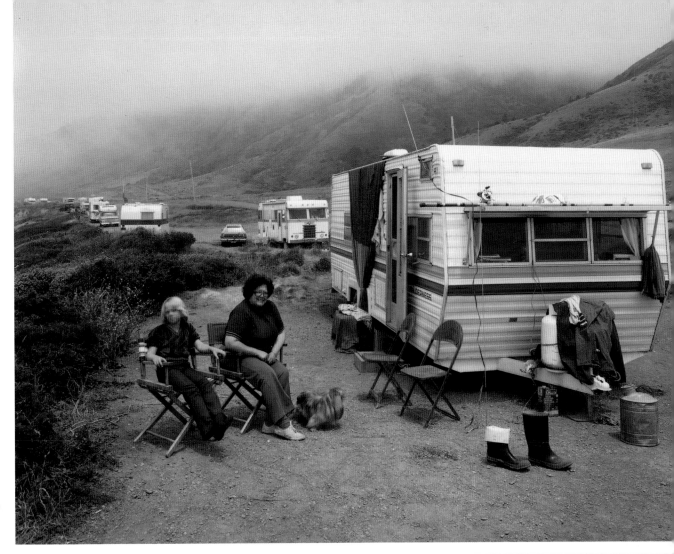

David Graham,
*California
Campers North of
San Francisco,
California*, 1981

Joel Sternfeld,
*Kickapoo
Indian Man at
the Only Water
Supply in the
Village, near
Eagle Park, Texas*,
1983

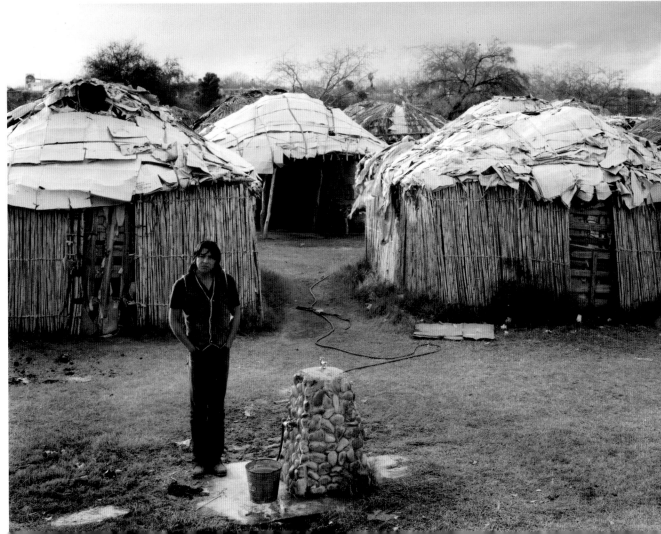

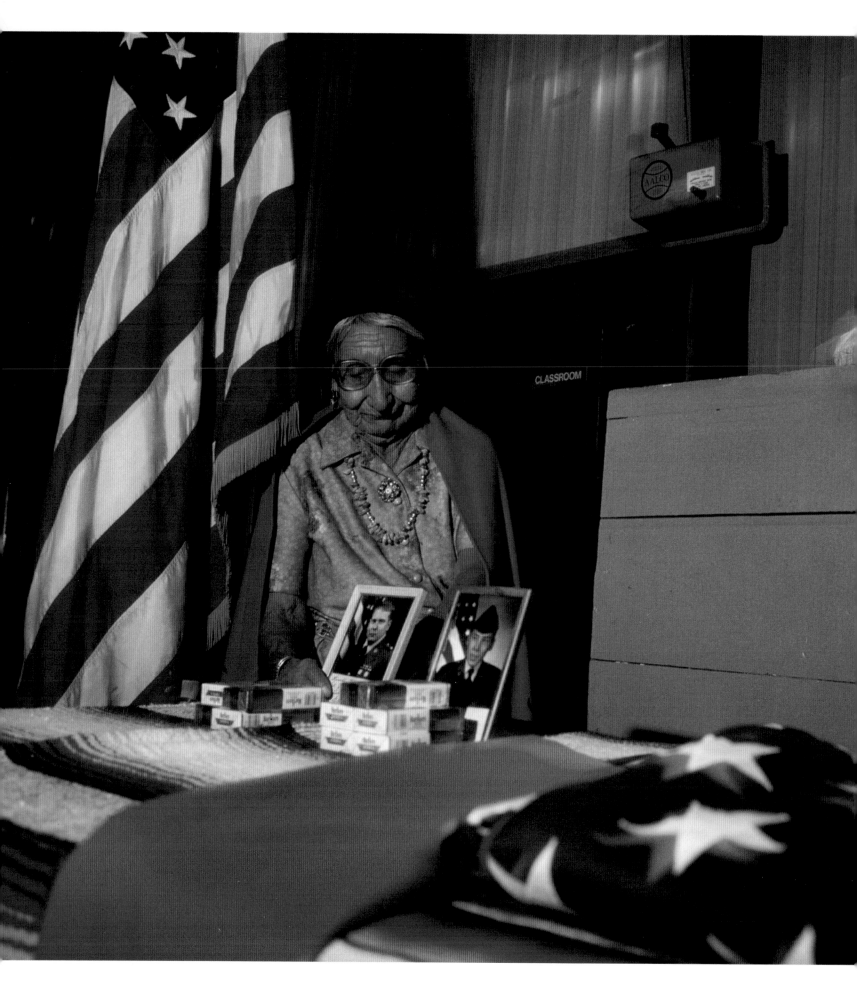

seeking their own histories: who are we? which act is this? what lines are we supposed to say?

In the Hardee's across the street from the Visitor's Center in Hopewell, I finally sat down one afternoon and re-read *Our Town* after more than a quarter of a century.

It has a lot to recommend it, as a play for adolescents. It's about a town resisting change, afraid to be a part of a much larger world, a town where diligence pays off, where there is no culture other than the church, and where "the lazy and quarrelsome . . . sink to the bottom." I did not remember one—not one—of Emily Webb's lines, as I thought perhaps I would, once I got back into it, not even this one, from Act One: "Mama, I made a speech in class today and I was very good," she says. "*It was like silk off a spool. . . .*"

A brochure I picked up at the Visitor's Center informed me that the first chemical plant to come to Hopewell was started by E.I. Du

*This is the only country in the world that's turned the Actor's Nightmare into a national group therapy, an identi-kit for tourists seeking their own histories: who are we? which act is this? what lines are we supposed to say?*

Pont DeNemours Company in the early 1900s, followed after World Wars I and II by Firestone, Hercules, and Allied Chemical.

If you've heard of it at all, this town, you probably remember it as the Kepone Capital.

The incidence of cancer here is five times higher than the country's average, for a town this size. My Greek mother died of it, and I am in remission.

Driving out along Route 1, leading back to Richmond, I thought about "silk off a spool" as something that those Greeks were, that their dreams were, coming into this country on the thin belief that there was work here in a *silk* factory. And then it hit me, I am staring at it, after all these years, and I pulled off the road and sat there, facing it, for a long time.

N-Y-L-O-N.

The silk factory.

Du Pont.

I used to think the fires on the ends of the smokestacks at night were purifying tongues of flame, burning like the fires I had heard about, that clarified the truth and did away with darkness.

I used to think that history was a place across a shadow line.

I used to think that I was not connected to the dolphins who were swimming in the James and Appomattox rivers when the English first got off their boats, bringing with them all their sows, bringing with them their silk purses.

Jeff Jacobson, *Pine Ridge Sioux Indian Reservation,*
*Pine Ridge, South Dakota,* 1990

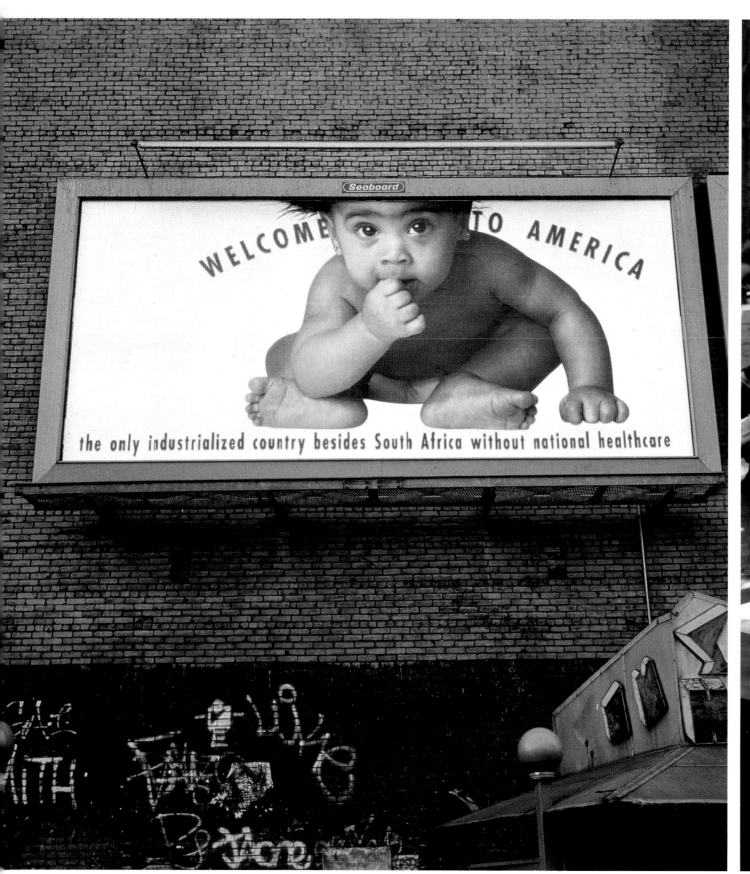

Gran Fury, *Welcome to America*, corner of Broadway and Houston Street, New York City, 1989

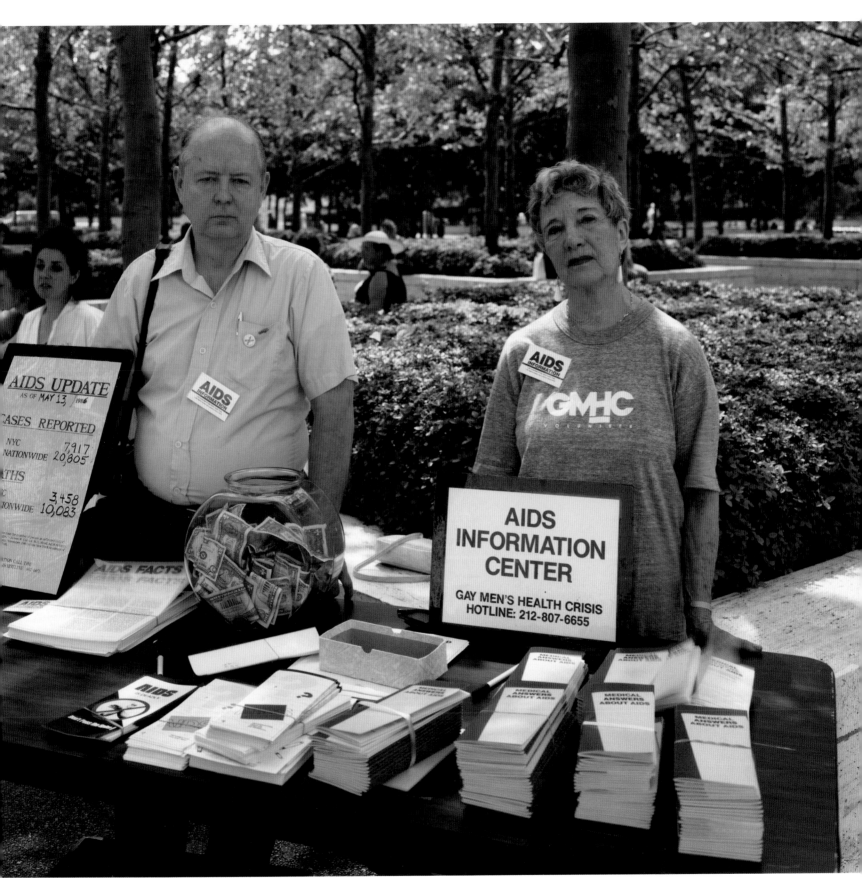

Joel Sternfeld, *AIDS Walk*, *New York City*, 1986

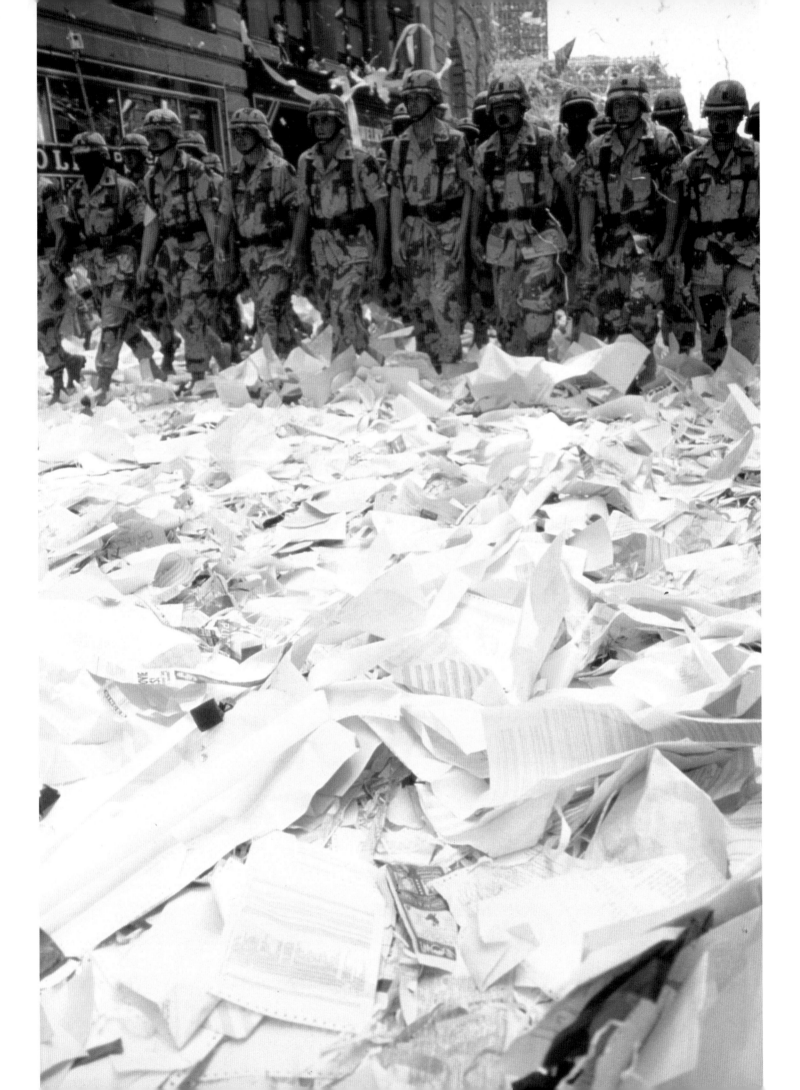

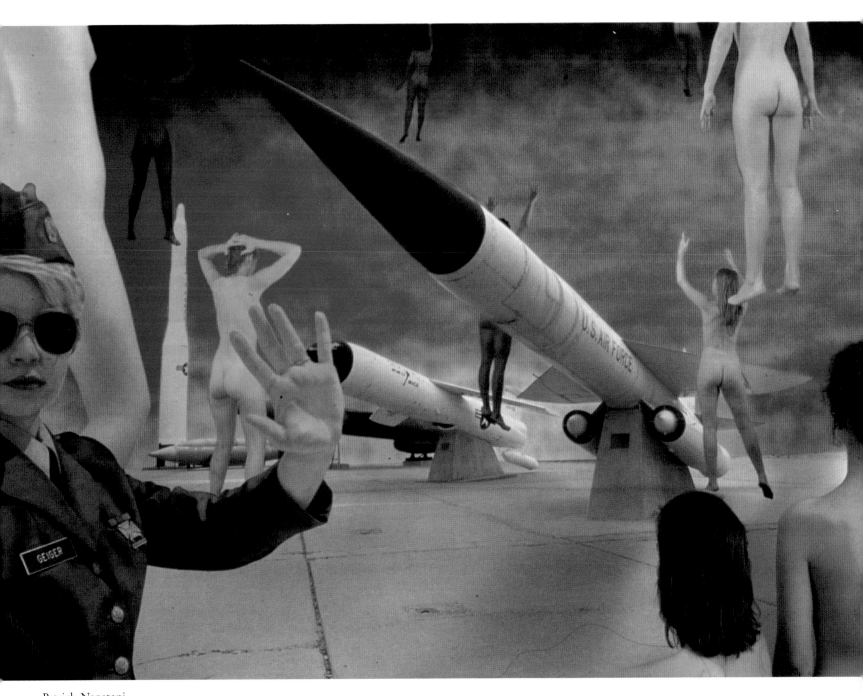

Patrick Nagatani,
*Lystistratus, National
Atomic Museum,
Albuquerque,
New Mexico,* 1989

*Opposite*, Susan Meiselas,
Operation Desert Storm
troops, New York City,
June 10, 1991

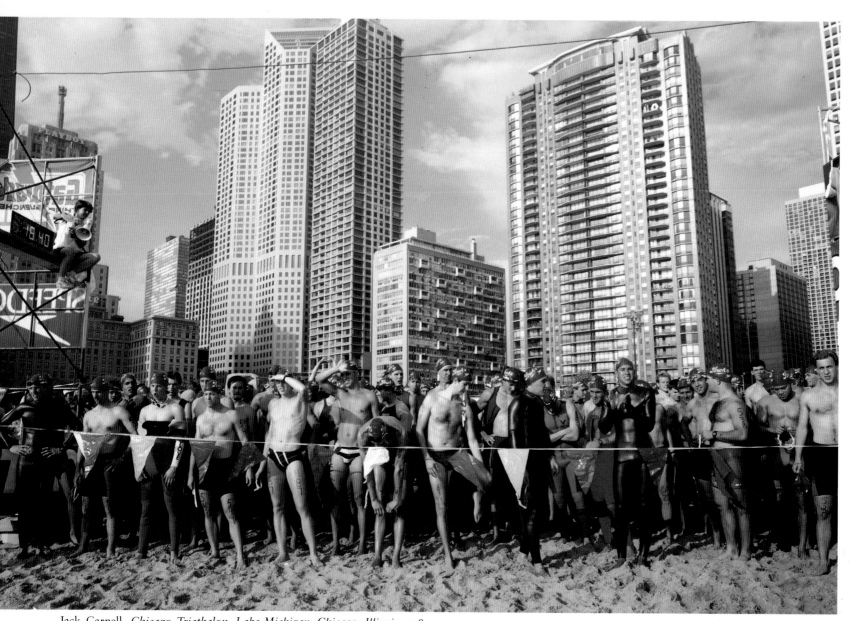

Jack Carnell, *Chicago Triathalon, Lake Michigan, Chicago, Illinois,* 1985

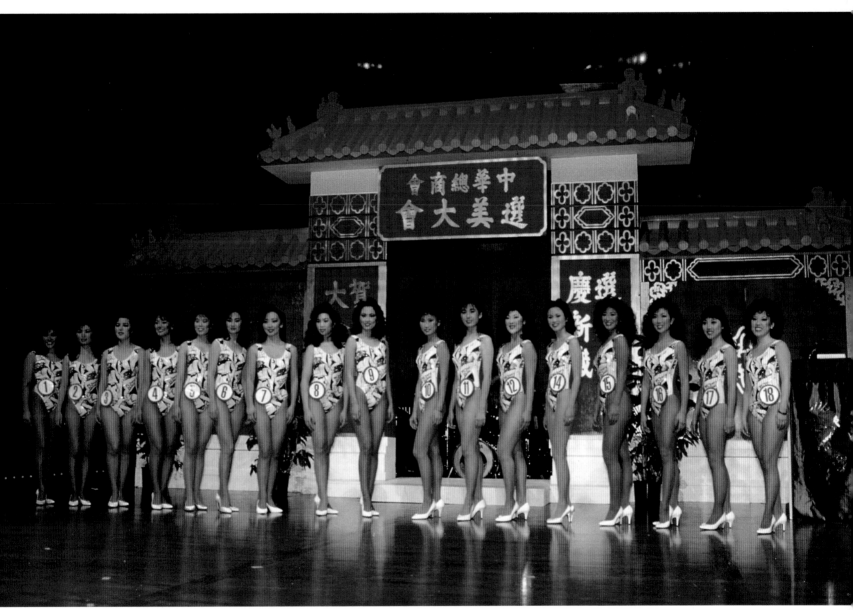

Patrick Zachmann, *Miss Chinatown U.S.A. Contest, San Francisco, California,* 1988

Joel Sternfeld, *Daniel Wolf Gallery Closing Party*, from the series "Aerial Party Pictures," New York City, February, 1987

John Leuders-Booth, *Outside of Boothill Saloon, Daytona Beach, Florida*, 1986

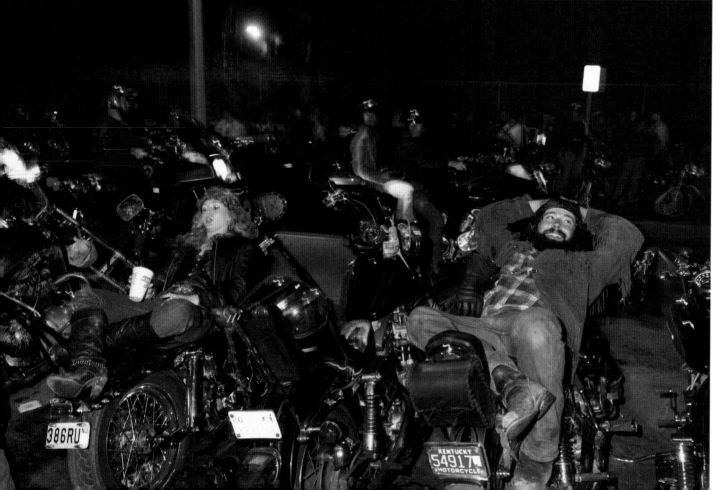

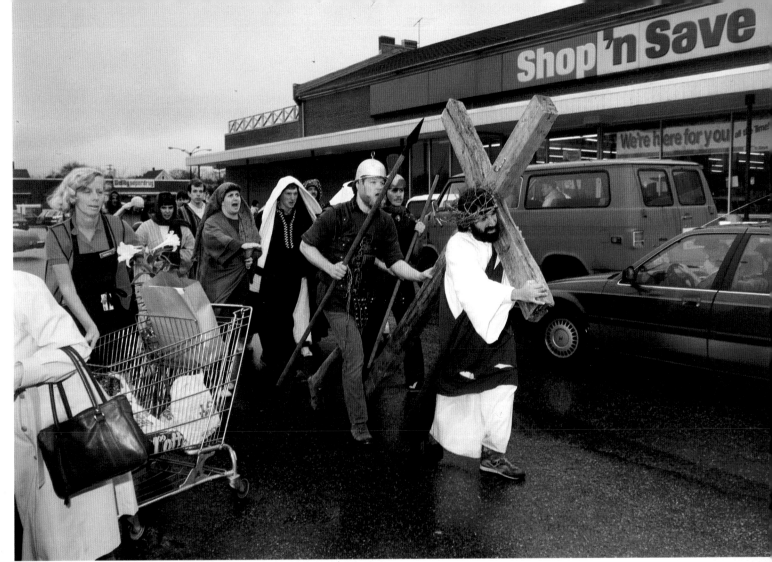

Ted Degener,
*Shop 'N Save,
Maine,*
from the series
"Religion in
America," 1987

Nick Waplington,
*Shopping Mall,
Menlo Park,
New Jersey,*
1991

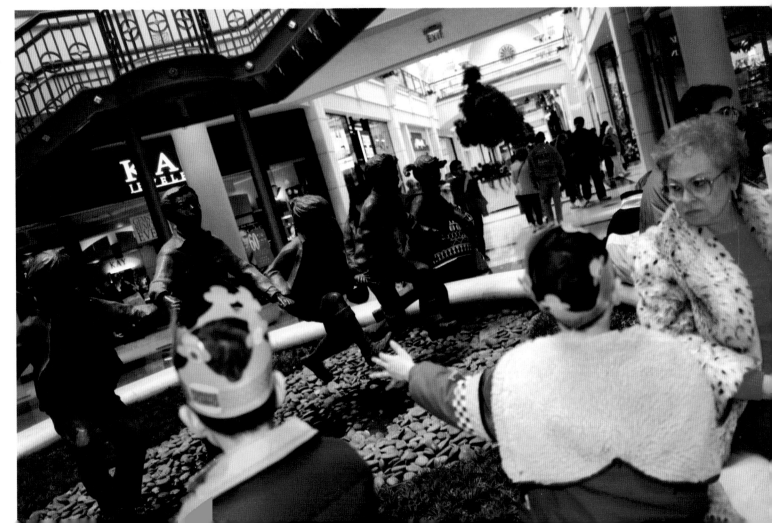

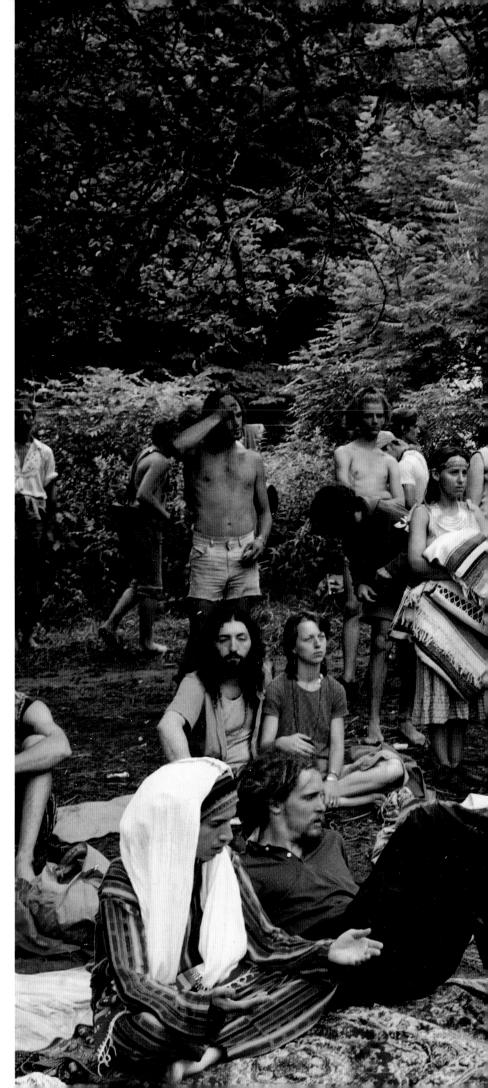

Ted Degener,
*Gathering,
North Carolina*,
from the series
"Religion in
America," 1987

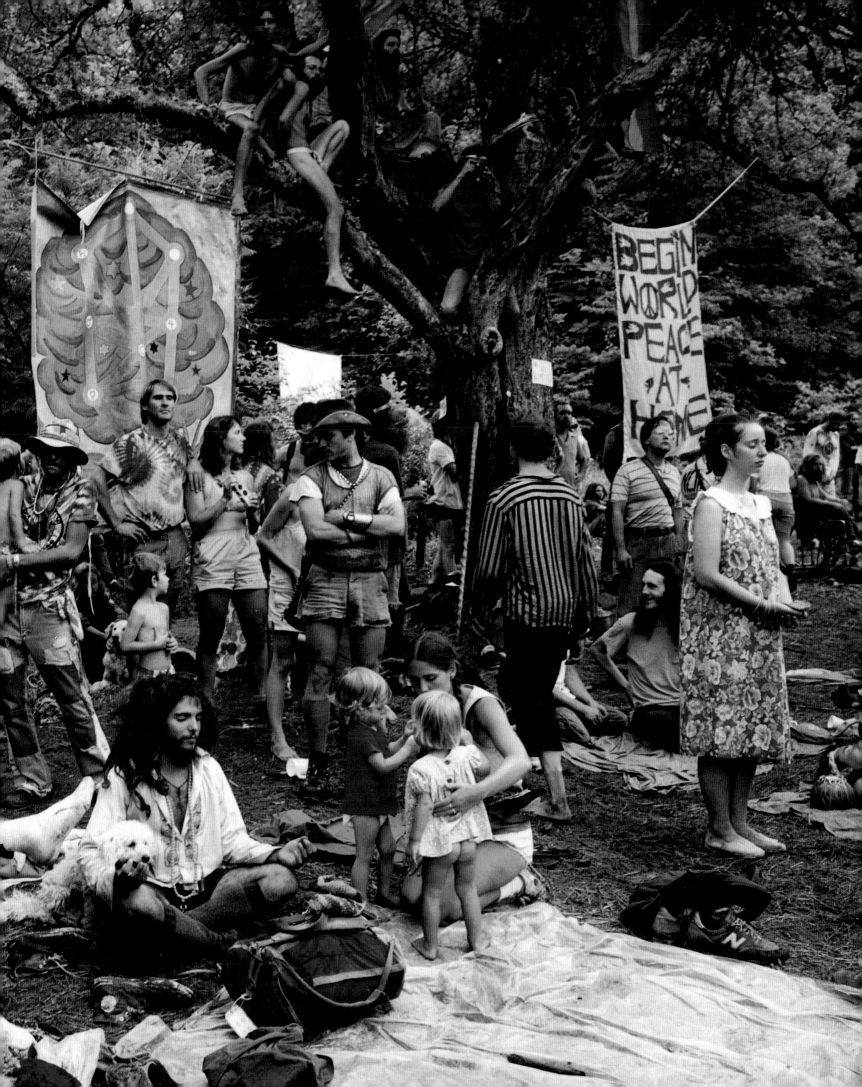

David Byrne, *Discount Shopping Mall near Plano, Texas,* 1985

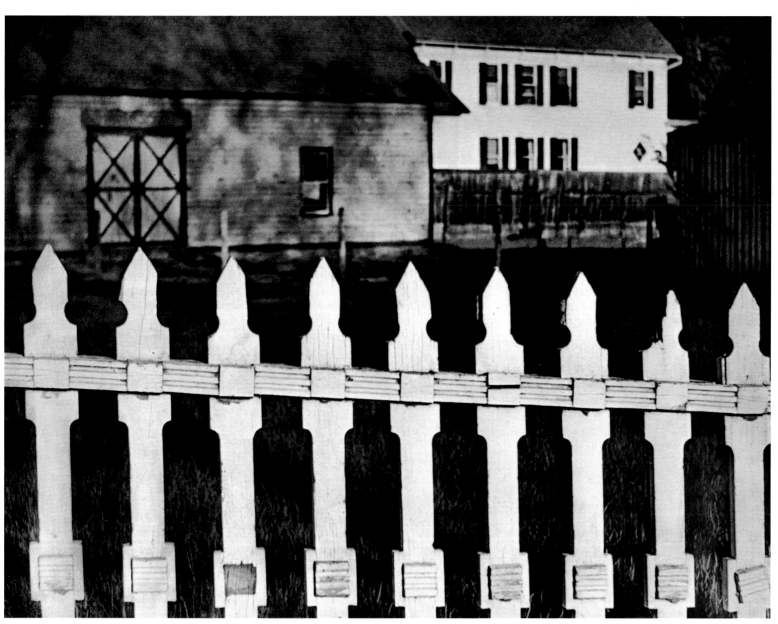

Paul Strand, *White Fence*, Port Kent, New York, 1916

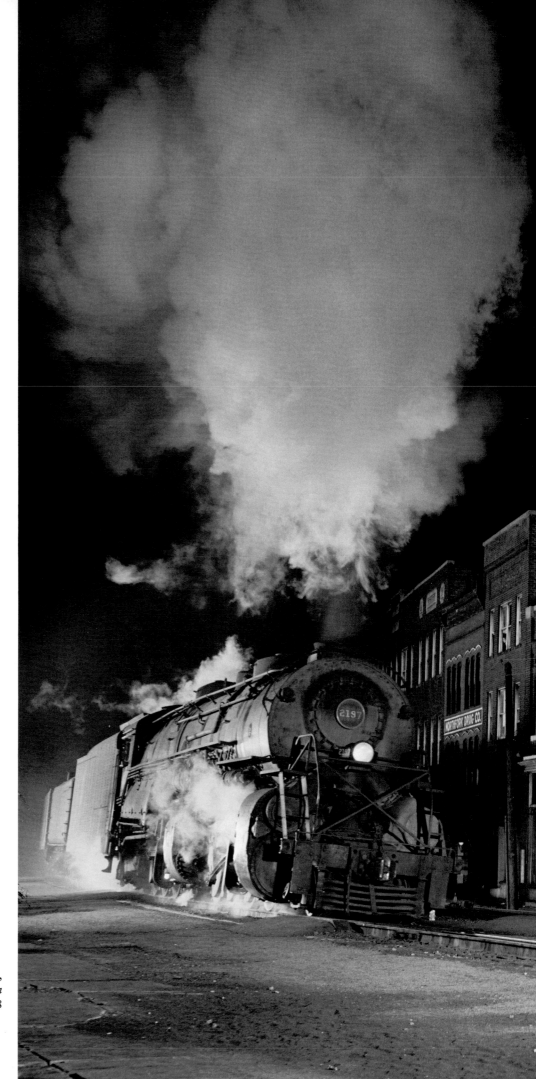

O. Winston Link,
*Main Line on
Main Street*, 1958

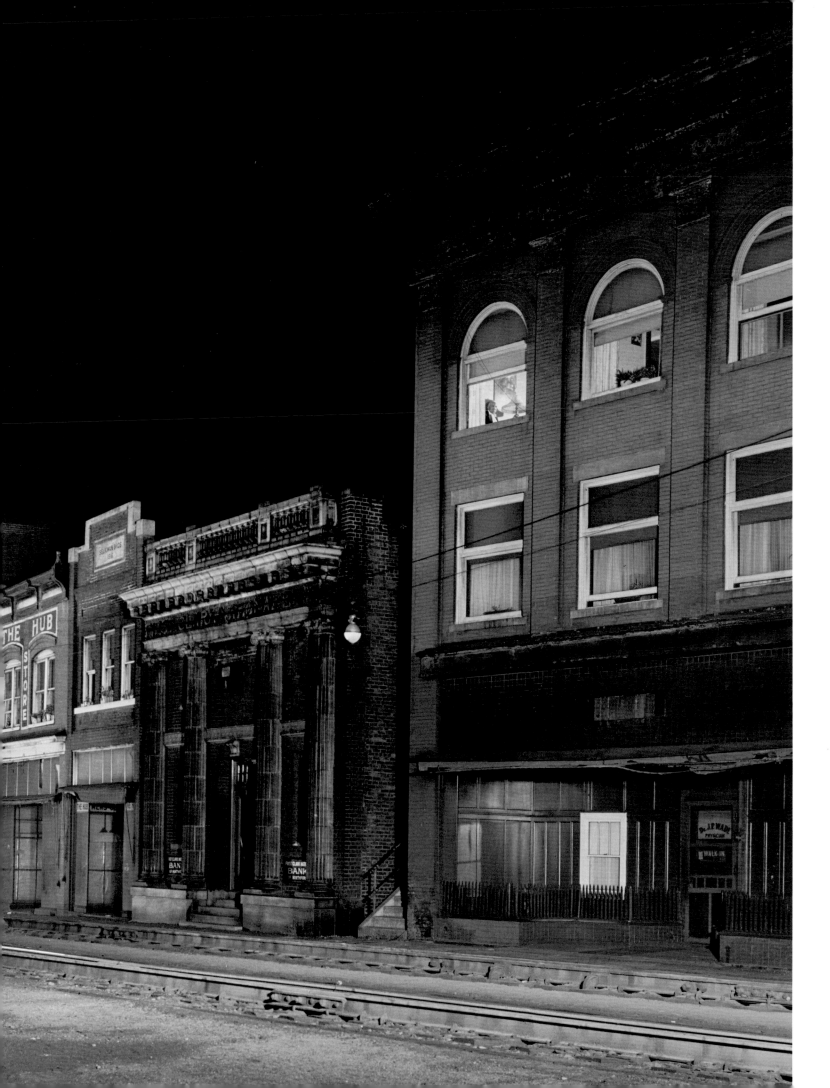

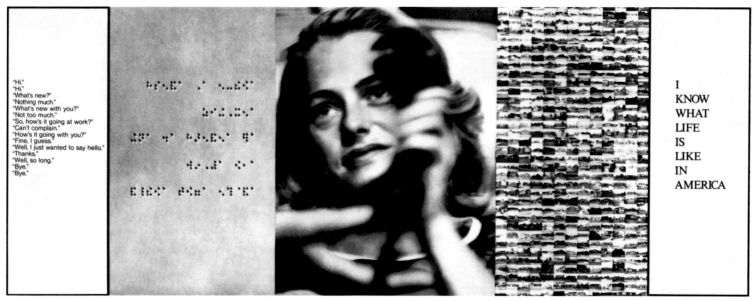

S. A. Backman, (*above*) *Selective Fictions, #32*; (*below*) *Selective Fictions, #16*, from the series "Double Entry," 1984–87

"I eat at McDonald's. I drive the freeway every day. I watch Johnny Carson. I use a 24 hour bank machine. I shop at Sear's. Isn't America great?"

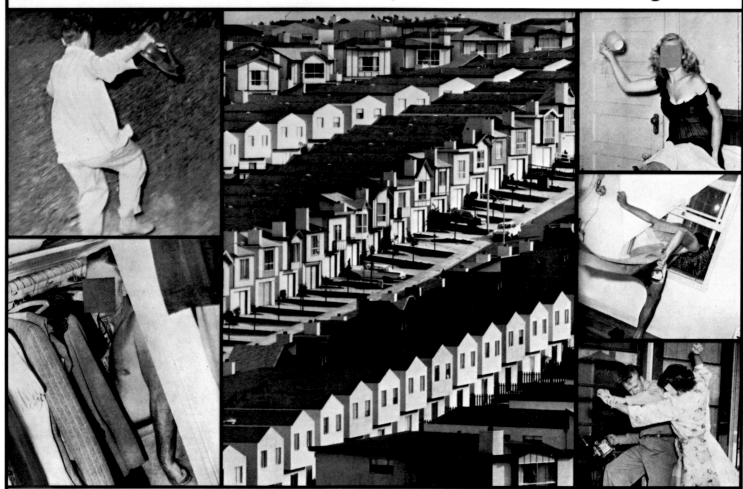

Throughout the Middle Ages there was less separateness between men and women. For example, privacy was considered unnecessary. Houses had no hallways; bedrooms served as passageways and sleeping places for married couples, their children, and other relatives.[8]

*Opposite*, Michael Spano, *One Way, 47th Street, New York*, 1988

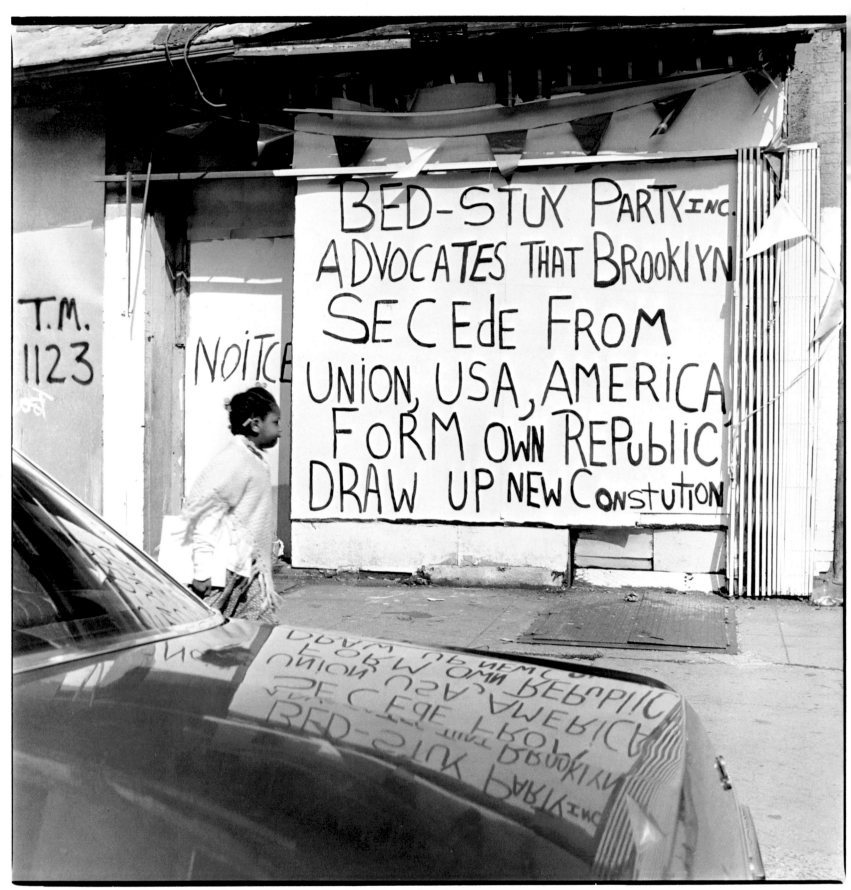

David Lee, Along Fulton Street in Bedford-Stuyvesant, Brooklyn, New York, 1985

# WHOSE TOWN?

## Questioning Community and Identity

### By Michele Wallace

When I was twenty-seven years old, a few days before Grandpa Bob (my father's father) died, he called to tell me about a Portuguese Jew, a slave owner who settled in Jamaica in the early nineteenth century and had children with an Ashanti woman. After the Ashanti rebellion and the emancipation of the slaves in the British West Indies in the 1930s, this Portuguese Jew married the Ashanti woman. They became my grandfather's grandparents—my great-great grandparents.

That day on the telephone, Grandpa Bob gave me the keys to learning something I've never forgotten about identity and community: both are realized through processes, the former of accumulated information and self-revelation, the latter of competing group conceptualizations and interests. Neither is immediately understood but rather unfolds over time, each in tension with the other, according to how curious and open one is to becoming aware of the inner logic and evolution of both.

My artist mother had divorced my musician father when I was two. I had grown up in Harlem knowing my mother's family best. They were originally from Florida and transplanted to Harlem in the 1920s. When Momma Jones, my mother's mother, would entertain us on Thanksgiving with stories about how Betsy Bingham, her grandmother (who seemed so very black in her photographs), was half Cherokee, everybody would collapse with laughter.

But perhaps because of these same stories, when I was in a position to pay attention to Native Americans, I did. Living in Oklahoma, the state that almost entered the union as Sequoyah, a Native American State, and in Buffalo, where there is a large Native American community, I studied the history of the Cherokee, their sojourns in Georgia, Tennessee, and Oklahoma, the forced removal of their Trail of Tears, and I learned that Momma Jones was probably telling the truth.

A socialist, an atheist, an astrologer, a horticulturist who was well read in several languages, Grandpa Bob strived to teach me, as I was growing up, a comparative sense of black community. With his facility for accents and his knowledge of the guitar, he re-created Jamaica for my childhood entertainment as an anarchic patchwork of ethnicities, dialects, and songs. Moreover, his stories about Harlem and the U.S. in the 1920s and '30s made clear that such diversity was effectively transplanted and further variegated in its new setting.

On the telephone on that particular day, the last time we ever spoke, he told me many things about his own and his family's history

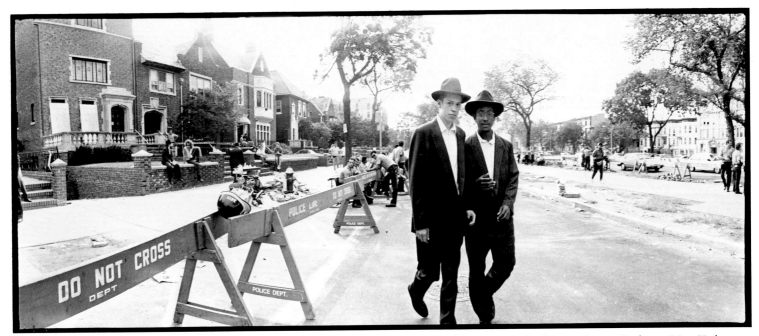

Sylvia Plachy, Crossing the color line on Eastern Parkway, New York, 1991

that he hadn't told me before. He had just finished reading my first book, *Black Macho and the Myth of the Superwoman*, and it must have occurred to him that as the family writer, I could make some immediate use of the information he was giving me.

Grandpa Bob's and Momma Jones's revelations led to my wanting to know how many great-great grandparents I'd had (everybody has sixteen) and how many I could account for. From then on, I began to wonder what a great-great grandparent was, indeed what a parent was. How many great-great grandparents determine one's identity? How many family locations in history determine one's community? How many races determine one's ethnicity?

Of course, the overwhelming majority of my ancestors were black and I grew up in a black neighborhood, which makes me black. But I like to think of myself as mixed, and as a citizen of the world. I never forget, have never forgotten since my grandfather told me, that I had a great-great grandfather who was a Portuguese Jew, anymore than I forget that I had a great-great grandmother who was Ashanti or another great-great grandmother who was half Cherokee and half African.

When events began to occur in Crown Heights and when Leonard Jeffries began to appear regularly on the evening news, and the assumption became law in the press — "high" and "low" — that blacks have become haters of Jews, for the hundredth time in the last decade I felt at a loss for "community." This feeling was only

# How many family locations in history determine one's

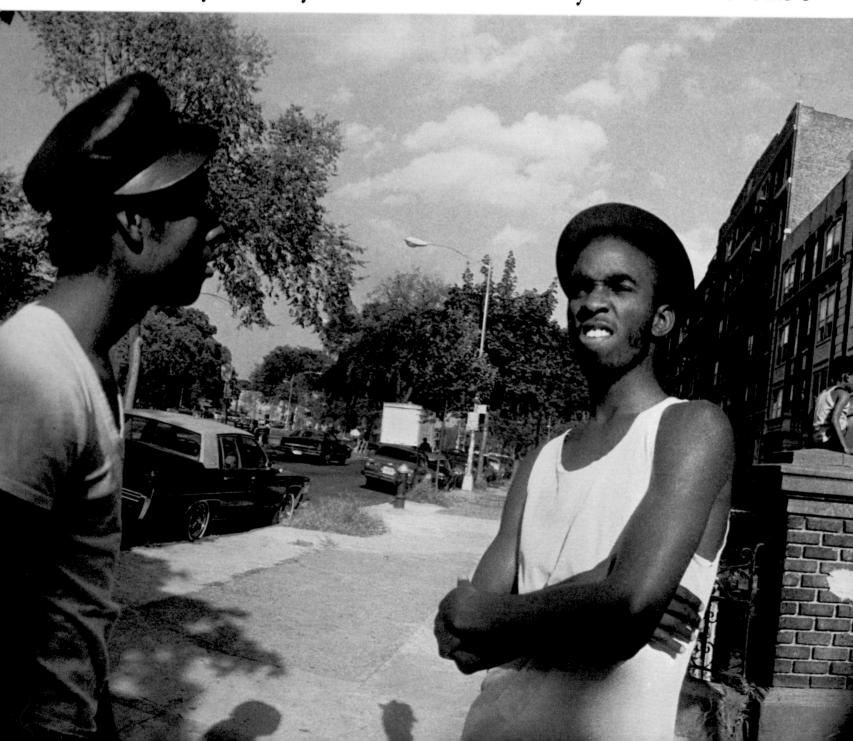

amplified when I saw that the hoards in the streets of Crown Heights—both the West Indian youth and the Hasidic youth—were predominantly male. No self-respecting woman could have any identification with such vigilante tactics on either side. Again I began to wonder about the nature of community and identity—do we establish these through class, race, turf, gender? Is each mutually exclusive of the rest?

Cries of racism were sparking debate at City College of New York (CCNY) long before Leonard Jeffries's infamous speech on July 20, 1991 at the Black Arts Festival in Albany. Dr. Michael Levin, a white professor of philosophy, had been publishing articles contending that "it has been amply confirmed over the last several decades that on average, blacks are significantly less intelligent than whites." Meanwhile, the black Dr. Jeffries was espousing his views with regard to the materialistic, greedy "ice people"—those of European descent, versus the humanistic, communal "sun people"—those of African descent. As for Jeffries's later remarks about the role of Jews in American society, which have been perceived as anti-Semitic, American Jews as a "community" since World War II have managed to transform their experience of oppression into a state of privilege, in part through their unconscious identification with a national system of white elitism. And some black Americans (not the smar-

Michael Spano, *Eastern Parkway, New York*, 1981

community? How many races determine one's ethnicity?

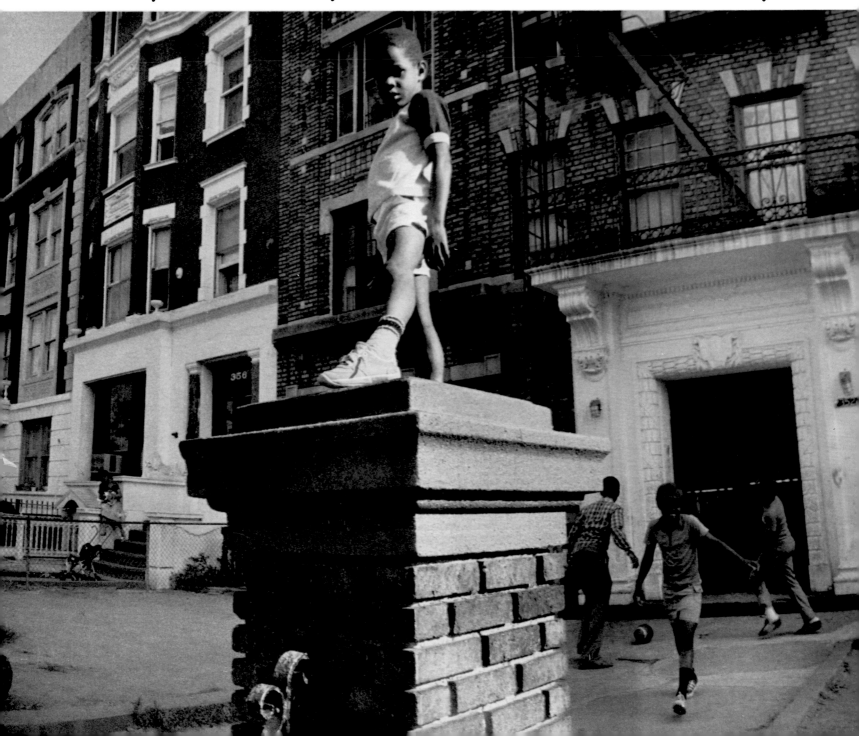

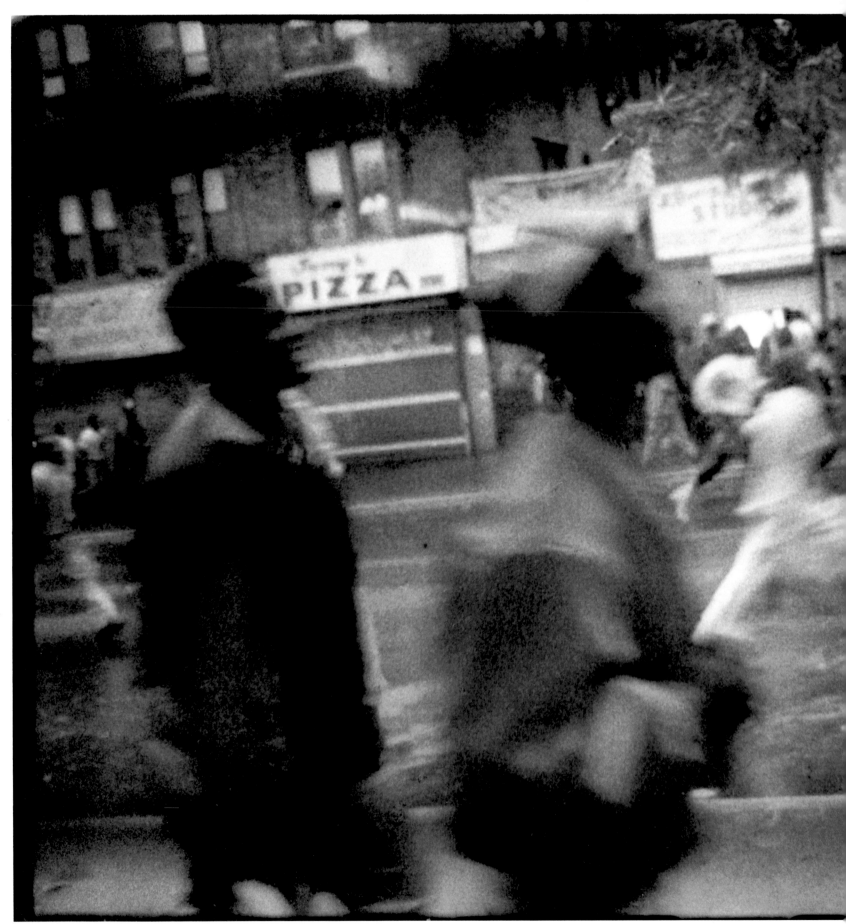

Sylvia Plachy, Rioters in Crown Heights, New York, Summer, 1991

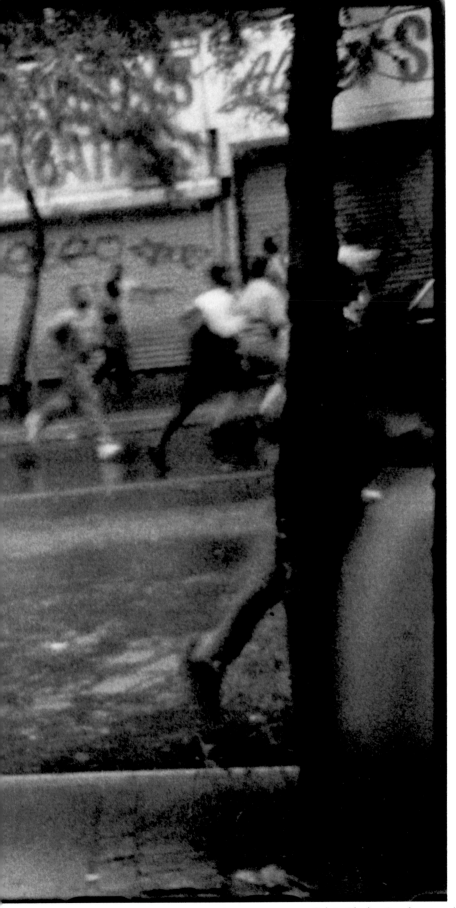

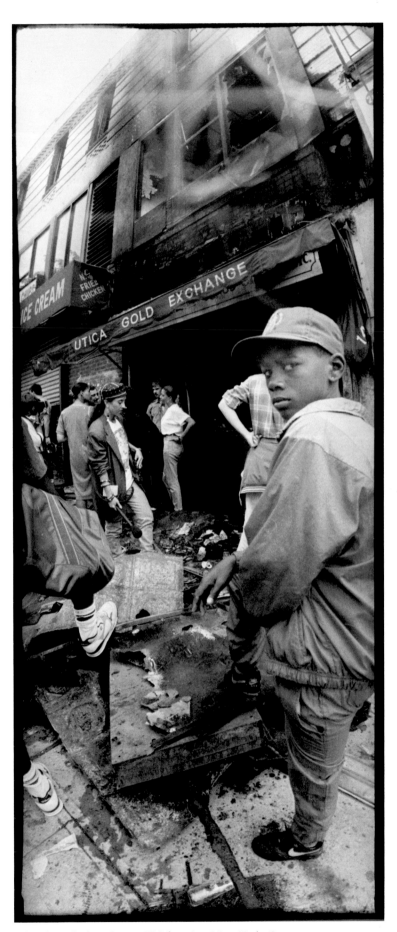

Sylvia Plachy, Jewelry store looted and torched in Crown Heights riot, New York, Summer, 1991

test, just the loudest, thanks to the press) may now be reacting to world systems of white dominance by an unconscious identification with anti-Semitism.

Twenty years ago, Jeffries was installed as permanent head of Afro-American studies at City College in Harlem (where I also teach). He was given tenure and a full professorship without publications. The Afro-American studies paradigm which Henry Louis Gates, Jr. at Harvard University; Houston Baker, Jr. at the University of Pennsylvania; and even Molefi Asante at Temple University have advanced is a program in which faculty are initially appointed in conventional disciplines in the humanities or the social sciences. Their courses are then cross-listed under Afro-American studies and/or women's studies and/or Latino studies. As a consequence of Jeffries's leadership style, most black professors in the conventional disciplines at CCNY choose to dissociate themselves from Afro-American studies. Nevertheless, the continued presumptions in the

press that Jeffries's speeches stand for "black community" in Harlem and at CCNY may destroy us, and in the process many good people who wish to preserve the delicate equilibrium of intelligent discussions about "identity" and "community."

Whereas Crown Heights and Jeffries were local New York fiascoes—albeit with national implications—whose focuses were primarily racial "communities" and where a few voices were said to represent many, the Anita Hill-Clarence Thomas hearings threatened (happily) to fully demystify the myth of a national black identity or black community. Besides the experience of sexual harassment, I share with Hill and with all other black women the negative "community" and negative "identity" of being a silenced black female subject in a world in which we continue to be represented only as objects. This is why, incidentally, our voices are so rarely heard in the press in times of national or local crisis. This is why nobody knows what informed female intellectuals of color

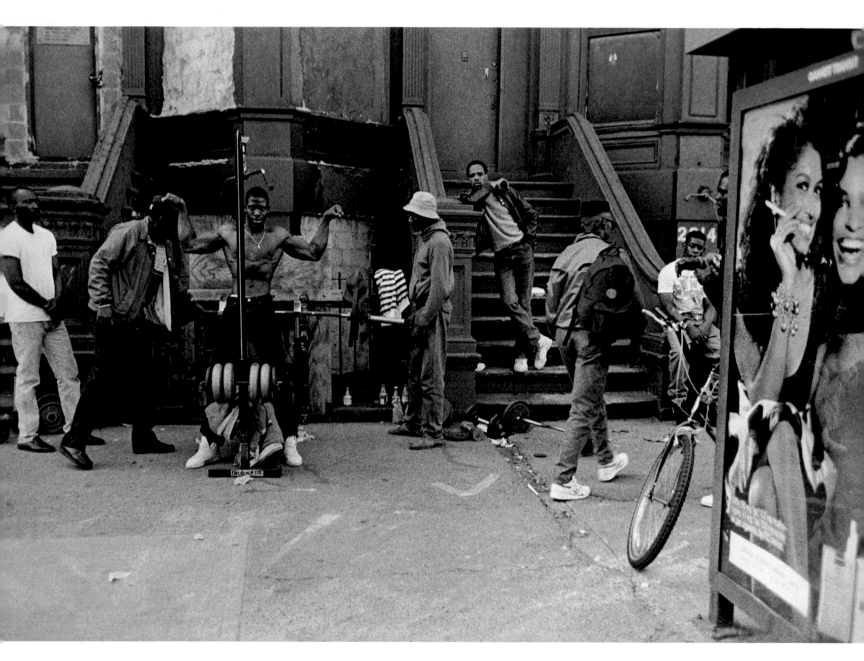

think about Crown Heights, or Leonard Jeffries, or Hill-Thomas.

Most black women—as their response to the hearings and their distrust of Hill proved—are unaware of their membership in a "silenced" community, their stake in a negatively constructed "identity." But some black women—as it happens the educated ones, the professional ones, the married and unmarried, heterosexual and lesbian ones who have touched the glass ceilings, floors, walls, and locked doors with their fingertips, and, indeed, rammed against them with their skulls—know that Hill is one of us.

Despite Hill's Bible Belt conservative Republican politics, and despite all the floating, socially and culturally constructed and negotiated identities of race, gender, class, sexuality, she has begun to learn the one thing that unites us as a conceptual "community," which we might call the black feminist community.

The difference between black women who are pro-Thomas and anti-Thomas cannot be fully explained by our membership in com-munities of race, gender, class, or sexuality—or identities forged in the mantle of same—but by how deeply we, as individual subjects, have had to become aware of the following painful fact: it is our job to fight for justice for black girls because no one else will.

What often has joined people together—forming perhaps the most powerful sense of community—has been the need to be heard. This fight for a voice is what black feminists, myself included, have in front of them. Hill, and white feminists, may call it the fight against sexual harassment. They may call it the fight to displace the members of the Senate Judiciary Committee. They may call it anything they like.

*Below right*, Donna Ferrato, Rosa Johnson on her daughter's wedding day, Oberlin, Ohio, 1988

*Left*, Jules Allen, *Untitled*, from the series "Hats & Hat Nots," 1990

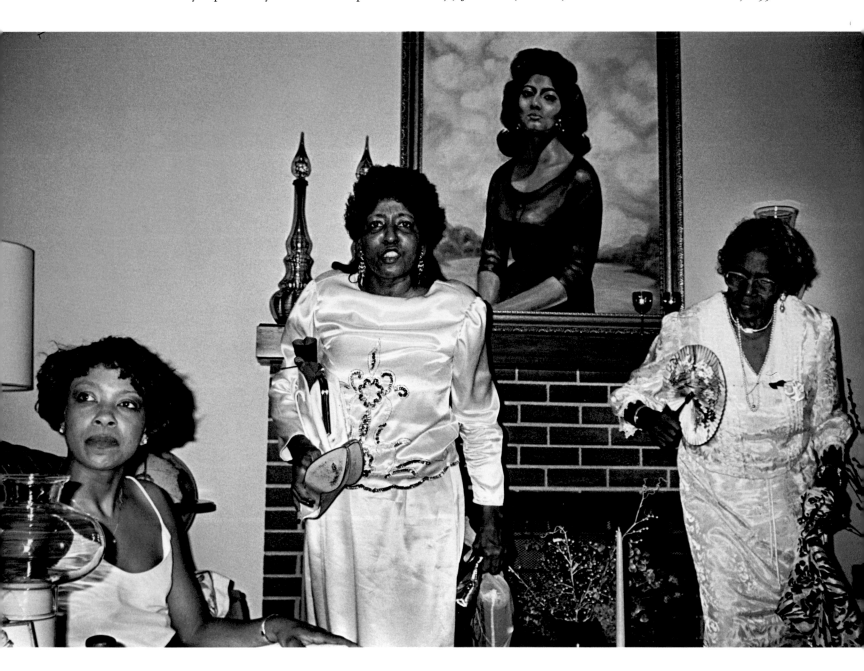

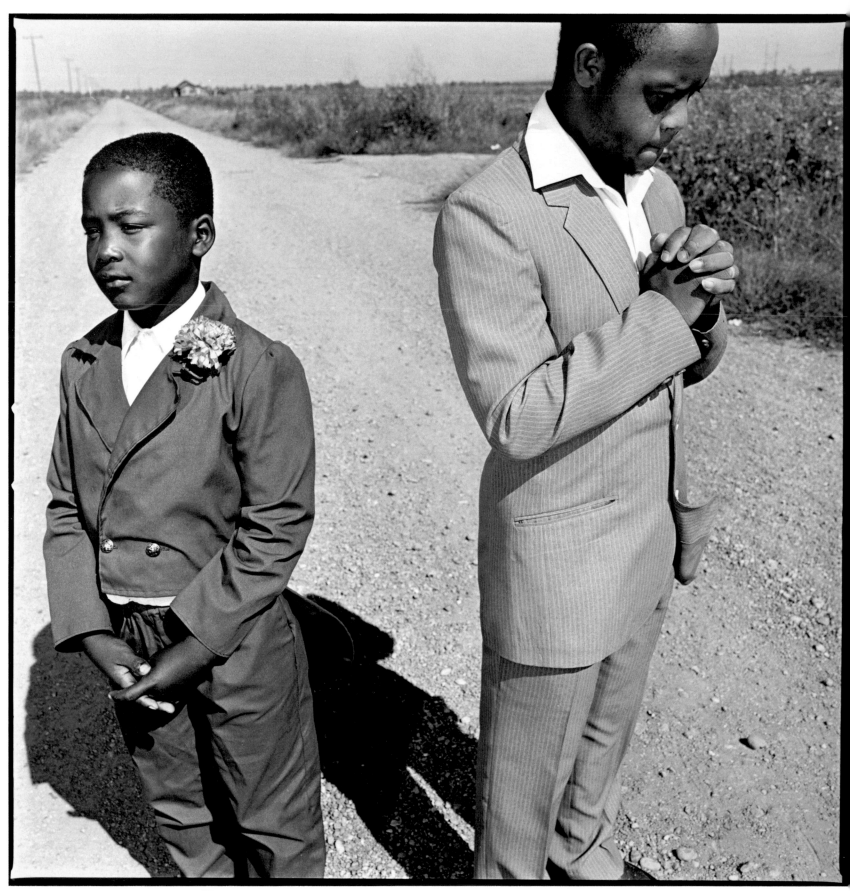

Mary Ellen Mark, *Antonio Pendelton, 7, and Roosevelt Scott, 20, St. Paul's Free Will Church, Tunica, Mississippi,* 1990

*Opposite,* Clarissa Sligh, *Waiting for Daddy,* 1987

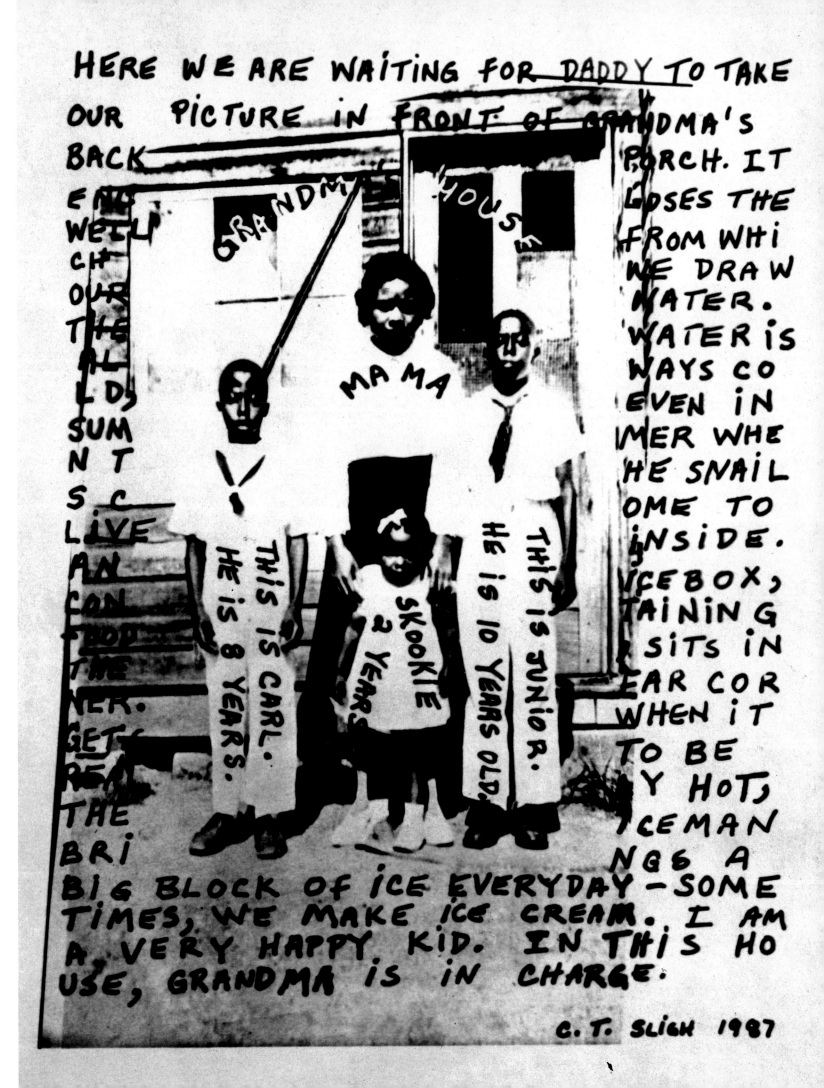

# APPALACHIA

## The Other Side of the Mountain

### By Shelby Lee Adams

When someone dies in the mountains of Eastern Kentucky, the custom is that after the body has been embalmed at the local mortuary, it is brought home for a two- to three-day wake before burial. Relatives, friends, and neighbors all bring flowers and food to the home for long day and night visits.

I arrived at the family home around five in the afternoon on the first day of the wake, bringing flowers and food. Standing in the entryway to the home, I immediately saw the photograph I wanted to make. The partition in the middle of the home divided two separate events. Memories from my own grandparent's wakes when I was a child flashed to mind. To the right, the formal parlor with the corpse displayed and children running around; to the left, the informal visiting room with people chatting, laughing, eating sandwiches, bouncing babies, and the general camaraderie that is so typical of country people.

At 9 P.M. that evening I returned to the funeral home with family members to attend a prayer service conducted by a local preacher. Having previously talked to the family members, I was asked to take pictures of the family and friends around the coffin. This is also a traditional custom throughout the Appalachian Mountains. After the service, I set up my 4 × 5 camera and location light kit. I made over fifteen different compositions around the coffin with different family members, friends, and relatives of the deceased. In addition, several 4 × 5 Polaroids were made and distributed throughout the group. After I had made all the photos the family had requested, I asked if I could set up my camera in the doorway and take a few pictures for myself. Everyone was cooperative.

As you can see from the watch the woman is wearing in the photograph, it was almost midnight when I took the image I had envisioned in my mind earlier that afternoon.

Shelby Lee Adams, *The Home Funeral, Leatherwood, Kentucky,* 1990

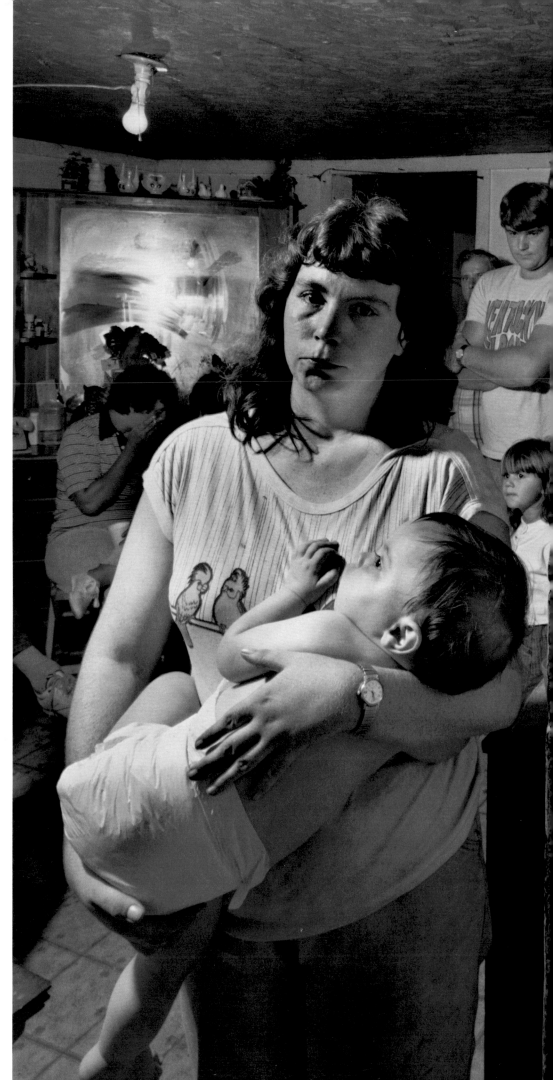

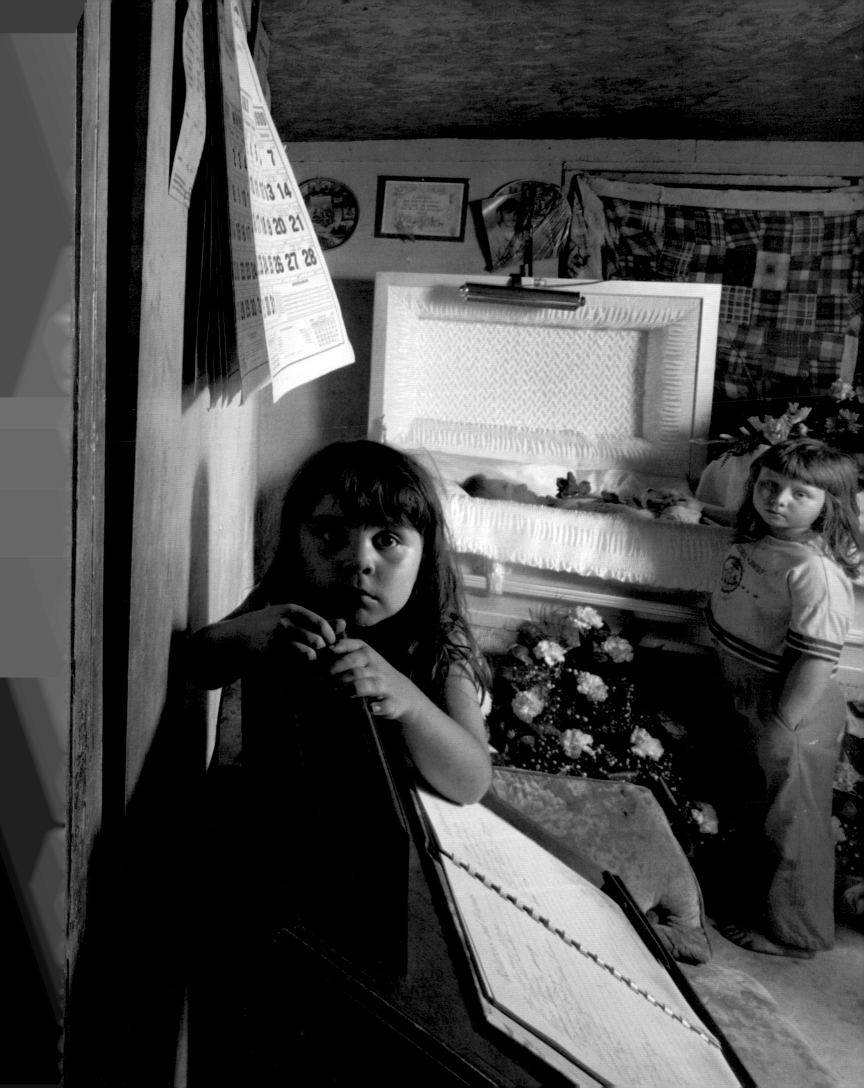

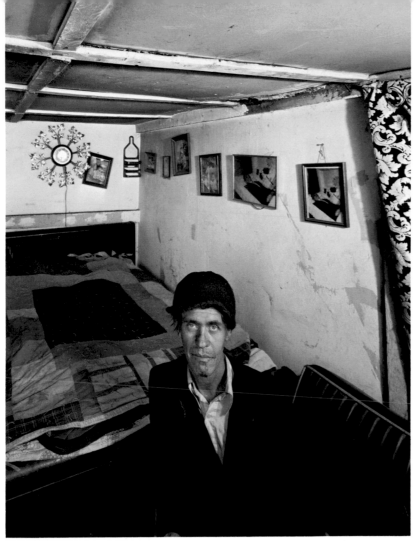

Arch Napier and his brother Jerry often got drunk and fought. One time Jerry shot his brother Arch in the stomach with a 22-caliber rifle from six feet away. Jerry received the knife scar on his face from a fight with another man over their mutual girlfriend *(right)*.

*Had sixteen children in my family, you wouldn't believe that, would you? Eight dead and eight livin'! Lord they drank and get out and get killed, and everythang. You know, you can't put sense on 'em. But when they was small, they mind me good, till they got to be twenty-two or twenty-three, now Laud have mercy.*

BERTHIE NAPIER, Beehive, Kentucky

Shelby Lee Adams, *Bert Sitting in front of Bed, Sloan Fork, Kentucky,* 1988      *103-year-old Woman and Family, Neon, Kentucky,* 1986

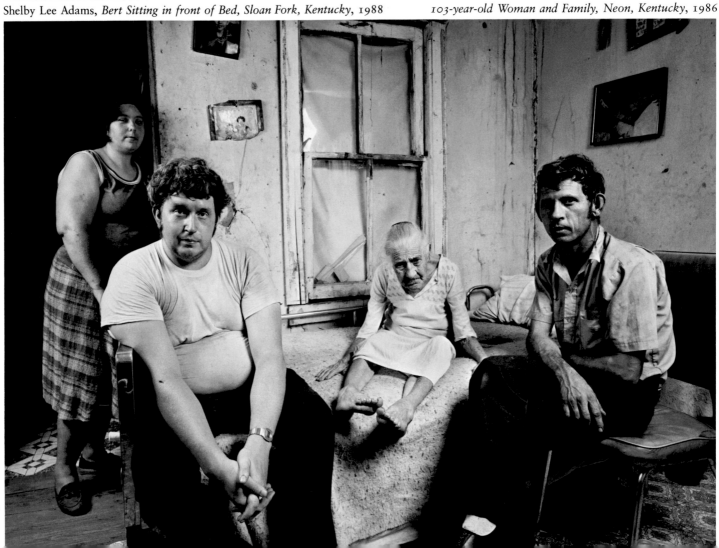

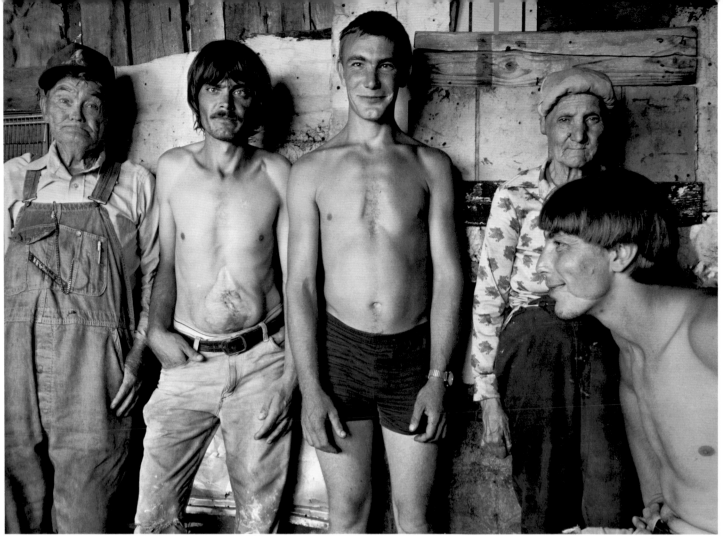

*The Napier Family, Beehive, Kentucky, 1989 (above)*

*George's Branch Porch, George's Branch, Kentucky, 1991*

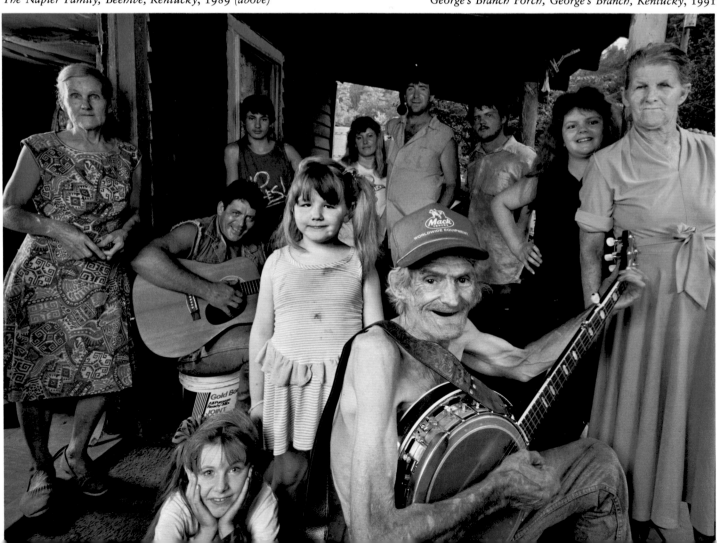

43

# THE FRUITED PLAIN

## By Nan Richardson

In that uncertain geography we call our national consciousness, agrarian culture has been celebrated as a touchstone from Emerson to Thoreau, from Muir to Frost. One of the earliest chroniclers of rural picturesque was Hector St. John de Crevecoeur, whose *Letters from an American Farmer*, written in the 1770s, was an early American best-seller at a time when America was a strip from Maine to Georgia 300 miles wide. Crevecoeur saw no beauty in wilderness, but instead found the American cultural identity in the collaboration between man and nature that defines the farm.

He was not alone: the first appraisals of American landscape were uniformly from a colonialist's vision, with an eye toward production—how this patch of nature would favor agriculture, shipping, settlement, trade, and bounty in general. Land was there to be won, not preserved. When by the mid-eighteenth century the English conceit of nature as a stimulant or balm to the mind took hold, the soul-stirring effects of natural wonders were duly photographed, and a Wordsworthian meditation on nature as metaphor for the frailty of the human condition took root.

Images of Thoreau's "indescribable innocence" proliferated: cows foraging in peaceful fields, sheep grazing on open meadows, and, in the background, the grain harvest. These smoothly contoured vistas provided a spiritual feast no less nourishing than the edible products of the land. But a different poetry of landscape was fast developing as westward expansion boomed; the moral minutiae of a domestic rural aesthetic gave way before the sweep and drama of craggy outcrops and epic plains, new symbols of the American character. The depiction of the traditional farm, like the European rustics of the Barbizon school, was reduced to pure Vergilian ecologue, a poetic metaphor less and less relevant with time.

That association of sentiment and rural landscape changed again with the economic tides. The Great Depression brought with it foreclosures on a grand scale, as farm income in 1931 plunged to a third of nationwide income a decade earlier. The visual evidence was no less stunning: in the high plain, a series of catastrophic droughts flung soil so far into the air that a thousand miles away in New York the sky was darkened by Dakota dust. Meanwhile, in Texas and Oklahoma, farmland only a generation old turned to sand and refused to bear.

A rural Armageddon was branded in our visual memory through the Farm Security Administration's definitive survey of American rural life, when Dorothea Lange, Walker Evans, Russell Lee, Marion Post Wolcott, and the other photographers hired to call attention to the "lower third" of society—the tenant farmers, migrant workers, and sharecroppers—made some 250,000 "pictures that altered

Robert Amberg, *Auction, Bishopville, South Carolina,* 1987

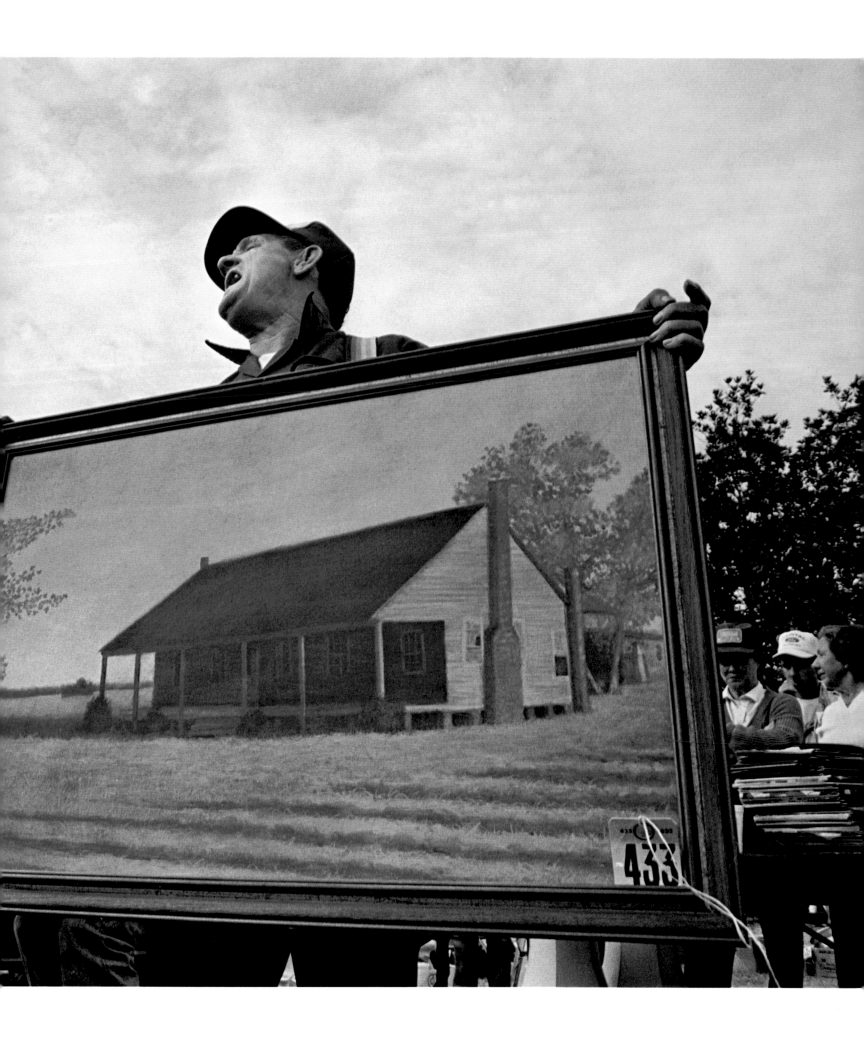

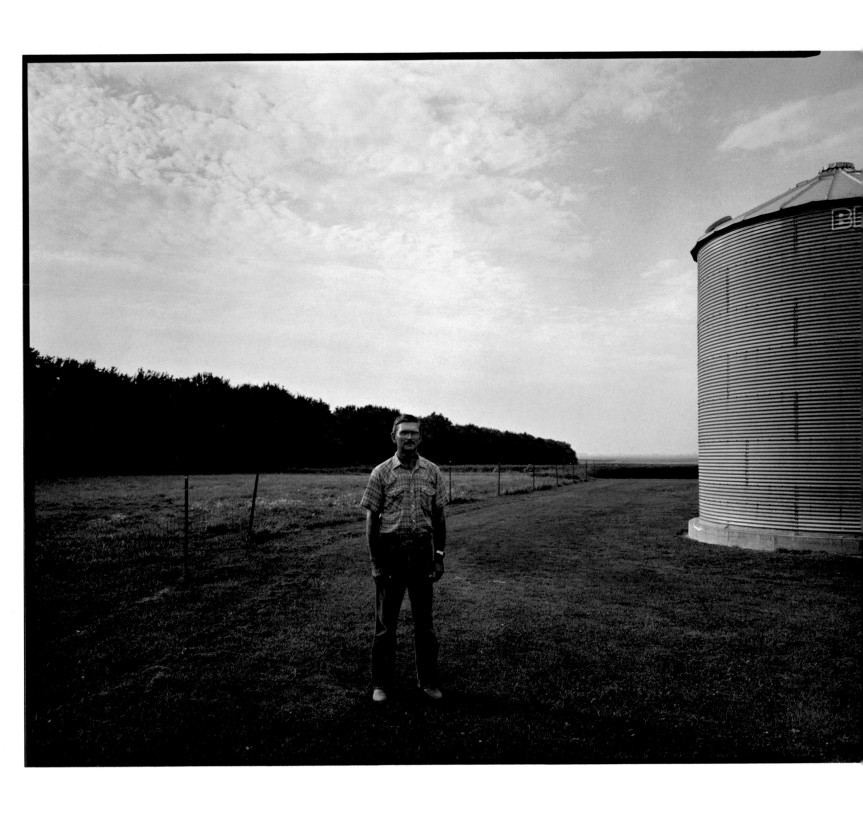

Rural communities are shrinking inexorably, losing first the

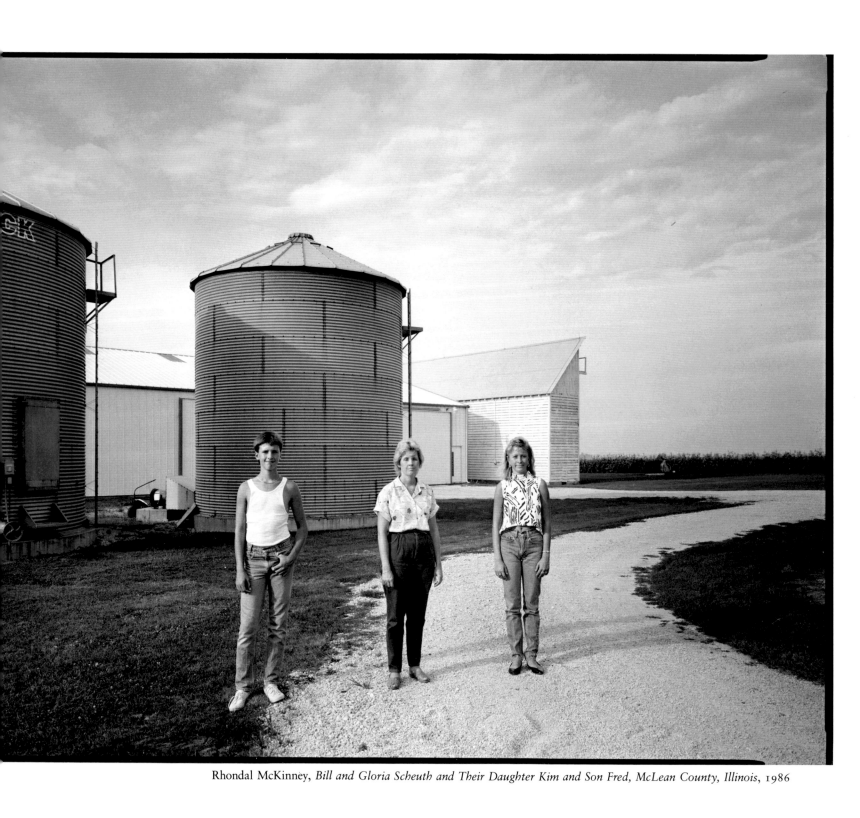

Rhondal McKinney, *Bill and Gloria Scheuth and Their Daughter Kim and Son Fred, McLean County, Illinois,* 1986

post office, then the café, then the school, lastly the church.

America." Considered subversive in their time, these images have taken on a new prescience in light of the current farm crisis.

For although the conquest of the United States by the plow has been an unchallenged article of faith, one on which American individualism and conservatism are dually based, the myth has died, as the incontrovertible statistics tell us: in 1900, 51 percent of Americans lived on the family farm, some 39 million people; today, only 3 percent of the population, or 5.6 million, inhabit our rural landscape.

Between 1979 (when the tractorcade marched on Washington to protest the rural collapse) and 1989, the number of farmers fell by 40 percent in the Midwestern states, and over 500,000 farms failed nationwide. Rural communities are shrinking inexorably, losing first the post office, then the cafe, then the school, lastly the church. Soon the roads themselves will disappear, lost in what once was called the Great American Desert.

In all this photography has played a central role, both as silent elegy to what has been, and as engaged criticism of the despoiling effects of human actions. Historically, rural picture-making, like most writing of the genre, has been defined by a painfully limited set of responses, veering between the sublime and the picturesque. The range from reverence (Eliot Porter and Ansel Adams), to the recording of natural grandeur (Carleton Watkins, William Henry Jackson, Timothy O'Sullivan and others mapping the "wilderness" for impending colonization), to mystical oneness (Edward Weston, Wynn Bullock and Alfred Stieglitz) is still embraced by the mainstream of landscape photographers.

In a deliberate rebuttal to this strategy, the "Topographics" of the 1970s (including Lewis Baltz, Robert Adams, Stephen Shore, and Frank Gohlke) added a cool formalist aesthetic to the genre, with an implicit moral admonition attached. Richard Avedon's eerie gallery of carnies, drifters, cowpokes, and beekeepers in the 1985 *In the American West* abstracted the degradation of the social fabric and the resulting isolation of the individual, alluding to a homely rural past replaced by the urban shadow of drugs, alcoholism, and broken families.

In a different vein, Richard Misrach's "Bravo 20," a white-hot depiction of military testing sites as harbingers of nuclear winter, joins works like David Hanson's study of nuclear-waste disposal sites (many of which are located in the rural countryside) and Robert Dawson's recent *California Heartland: The Great Central Valley* as Cassandras to an eroding future. Another of Misrach's series of images, titled "The Pit," focuses on the mysterious death of livestock in very close proximity to a former nuclear test site in the Nevada desert, and the nearby pits where the animals were dumped. These photographs of rotting carcasses, like the deceptively serene landscapes in "Bravo 20," serve as a chilling commentary on man's willingness to destroy that which bears in favor of that which kills.

The larger field of landscape photography has embraced an increasingly muscular advocacy role, and farm photography, though still presenting a definition of rural as a perennial source of beauty, comfort, and escape from the delirium of urban life, does so with a newly elegiac note.

Among work that presses home the issues and beauty in equal measure must be numbered Rondal McKinney's long-term study in panoramic pictures of his rural neighbors in Normal, Illinois, which has helped articulate his own passionate activism: "When the cost of borrowing was low, farmers borrowed big, with the eager encouragement of bankers and government officials, an average million-dollar debt for a medium-sized farm. By the early 1980s the squeeze came so inexorably that many were forced to sell. Large corporations, cartels of investors and even foreign speculators bought the land, driving prices beyond the reach of the average local farmer. To meet the short-term need for capital, many farms over-chemicalized, despite agronomists' warnings. Absentee landlords with no long-term commitment to the land allowed cash renters or sharecroppers to farm, who had no incentive to conserve or improve. Fence rows were torn to increase tillage acreage, though this increased wind erosion (not to mention loss of wildlife habitat).

*We are experiencing a crisis of character that hearkens back to legends of the exploration, clearing, and tilling of America that extoll pathfinders, heroize cowboys over Indians, but also mythologize bringers of civilization . . .*

They computerized, industrialized, amortized, and politicized the family farm."

A very different landscape is depicted by Rob Amberg, who has lived for nearly twenty years in a small town in the mountains of western North Carolina. The mountainous acreage doesn't admit tractors, and the work of growing and harvesting tobacco is done, as it has been for generations, by hand. Amberg's long-term involvement in the subject accelerated in the 1980s when he started photographing for a farm-advocacy organization, spurred on by the high attrition rate for farms in the region. "Some five thousand farms disappeared from North Carolina in the 1980s," Amberg commented, "but even that statistic is not as shocking as another, that there are only 180 black farmers under the age of twenty-five in the United States, and that black farmers are two and a half times more likely to lose their farms than white farmers. Because that suggests the real crime here: a kind of genetic information, a knowledge of the land, and a husbandry with animals, that is being lost forever."

Jerome Liebling sounds a similar note, describing himself as having "moved away from the highly politicized years" of the Democratic Farmer Labor party in Minnesota. Liebling now lives in the western Massachusetts of small farmers and part-time farmers, where the harvest is brought in by the high-school students, or, in the case of tobacco, by contract labor: "Jamaicans, mostly," he clarifies. Still, similarities between the two communities endure. Liebling notes that, "These people relate—in the crudest way—to a spirituality that no one in urban centers has. Not that I look for any

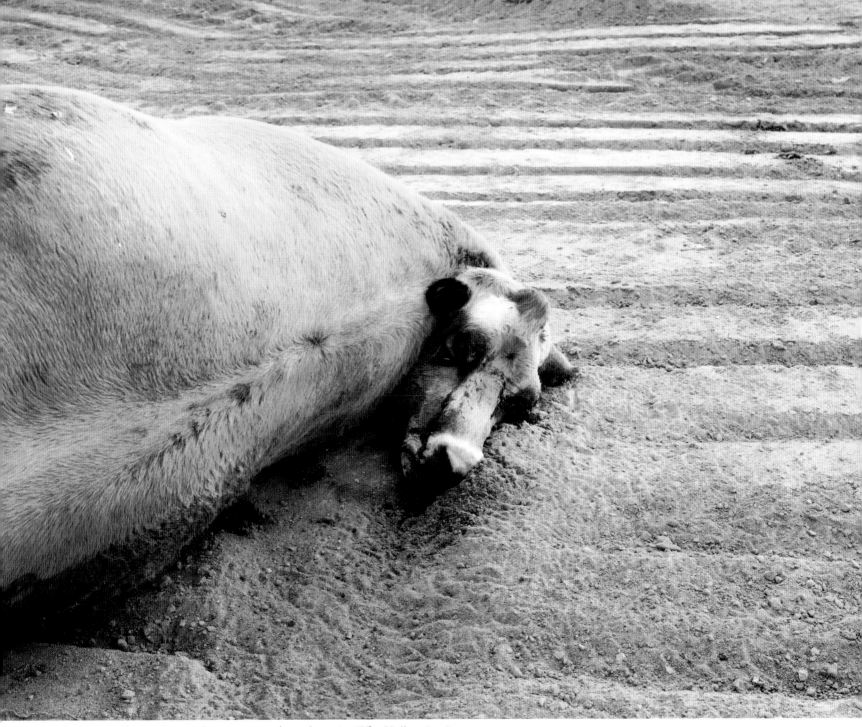

Richard Misrach, *Dead Animal #454*, 1988, from the series "The Pit," 1987–89

repetition of images from Millet but they seem to appear in a kind of choreography of the human body."

It is a near-painterly picture of the Amish countryside in softly romantic hues that Lynn Butler's Cibachromes create. Impressionistic in effect, they treat the delicate creative reanimation of the natural landscape found in eighteenth-century canvases. Part of a meditation on the transformation of the past, this dreamlike sequence continues themes present in Butler's previous work, notably her "Sleepy Hollow" series, revisiting Washington Irving's Hudson River Valley tale (and, like the headless rider of that national myth, photographing from horseback). This pastoral quality also char-

acterizes images made by Suzanne Williamson, whose delicate, black-and-white photographs of grassy meadows, cornfields, and farm animals made with a Diana camera are paeans to decay and disappearance.

David Husom's exhaustive series of rural Midwestern county fairgrounds architecture (encompassing all of the ninety-four county seats in Minnesota) is part of the long tradition of typological studies in photography, led by August Sander and most recently celebrated in Bernd and Hilda Becher's water towers. In a similar vein, Stuart Klipper, who is best known for the austere and icy beauty of his panoramas of the Antarctic, has been quietly at work

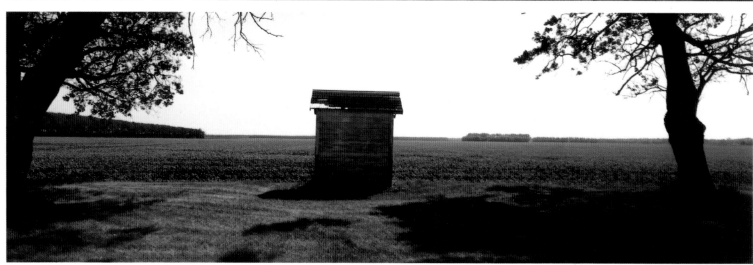

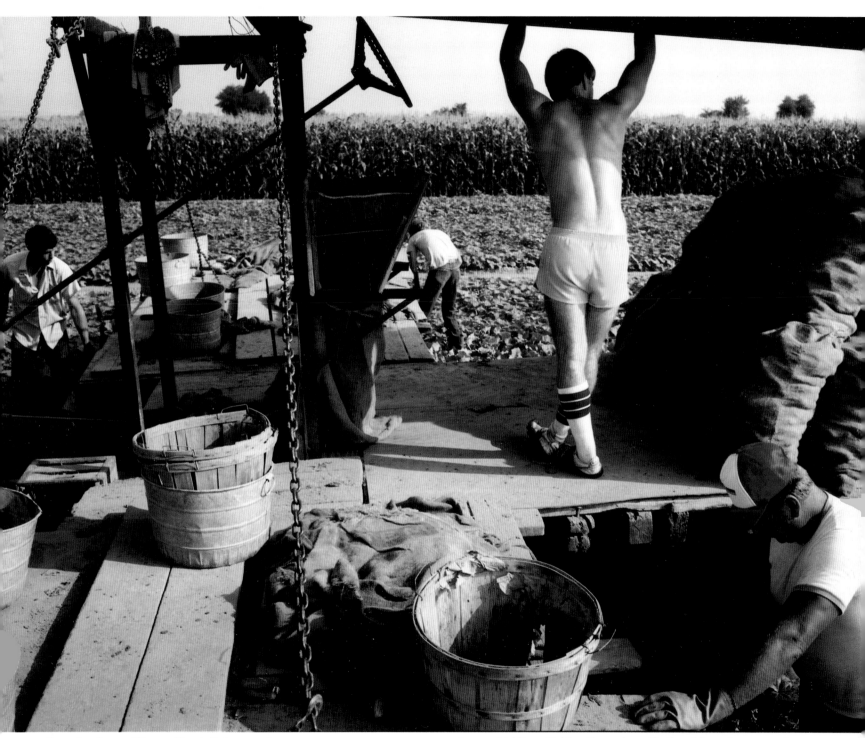

*Opposite,* Stuart Klipper, *North Dakota,* 1989          Jerome Liebling, *Picking Cucumbers, Hadley, Massachusetts,* 1984

on a more gentle and yielding landscape. A kind of cultural geographer ("even metaphysical geography is enough to attract," Klipper notes), his far-ranging survey of natural views and indigenous architecture in the Midwest are part of an attempt after each glacial expedition to anchor himself on home ground.

Archie Lieberman, a sixty-nine-year-old photojournalist from Illinois, has photographed the family of Bill and Mildred Hammer for thirty years, returning over and over to make a record of daily life in the remote hilly farmland; Janet's thirteen-year-old brother Bill became the centerpiece of Lieberman's 1974 book, *Farm Boy*. And when Bill's son, Jim, grew up, Lieberman photographed him, "the seventh generation of Hammers on the land." "It's like *Our Town* to me," Lieberman says of his obsession, "and I have to be true to them . . . I don't want to betray these people."

An exploration of the enduring sense of rural community is also evident in the work of Tom Arndt, who has focused largely on group

*New Mexico State Fair, Albuquerque, New Mexico, 1983*

*The larger field of landscape photography has embraced an increasingly muscular advocacy role, and farm photography, though still presenting a definition of rural as a perennial source of beauty, does so with a newly elegiac note.*

rituals: the cattle auction, the slaughterhouse, a threshing bee, Christmas dinner, a twenty-fifth anniversary party, a funeral. "Any crisis on a farm affects the entire family, then percolates through the community—to the Ben Franklin store, the feed store and the gas station," Arndt comments.

If our sentimental national attachment to the farm is, in the words of writer Barry Lopez, a "longing for wholeness," weakened in the face of global economic pressures that have resulted in a half million miles of the richest land in the world becoming infected with lethal chemicals, drained and contaminated aquifers, spiralling land prices, and plummeting crop prices, the crisis in land use has forced an ethical reexamination of our priorities. We are experiencing a crisis of character that hearkens back to legends of the exploration, clearing, and tilling of America that extoll pathfinders, heroize cowboys over Indians, but also mythologize bringers of civilization: Johnny Appleseed, Davy Crockett, Paul Bunyan, and George Washington, the farmer who left his plow to become a soldier and shunned glory to return to the humility of tilling the land—our own Cincinnatus.

While we have come far from Crevecoeur's description of the American farmer—"his is the most important national activity . . . all other forms of economic life are parasitic upon it"—Americans are still fed by the land in ways that transcend our dependence on it for food. Rural imagery today, like the broader field of landscape photography, will be seen, and depicted, as both an aesthetic refuge and a battlefield.

All photographs by David Husom

*Missouri State Fair, Sedalia, Missouri, 1981*

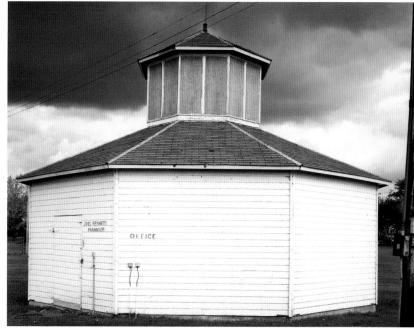

*Kanabec County Fairground, Mora, Minnesota, 1978*

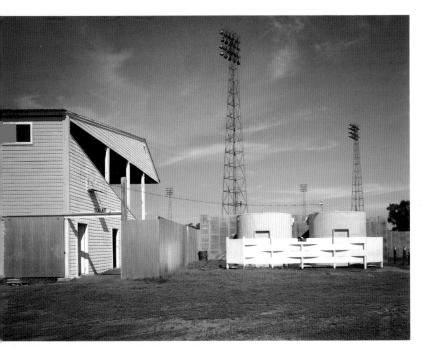

*Pine County Fairground, Pine City, Minnesota, 1978*

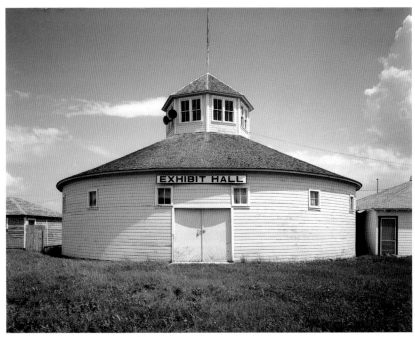

*Traverse County Fairground, Wheaton, Minnesota, 1980*

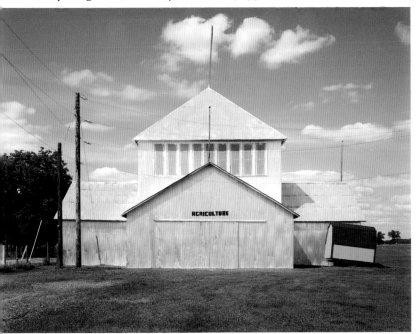

*Todd County Fairground, Long Prairie, Minnesota, 1979*

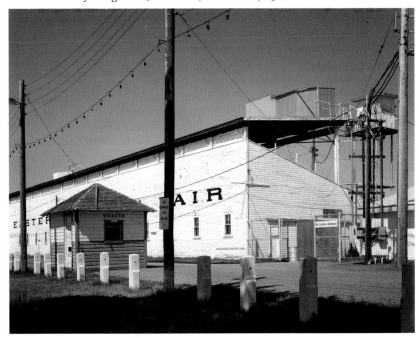

*Eastern Montana Fair, Miles City, Montana, 1983*

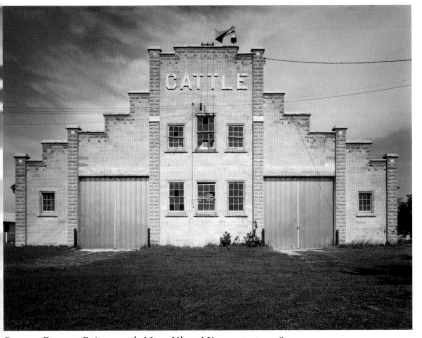

*Brown County Fairground, New Ulm, Minnesota, 1978*

*Isanti County Fairground, Cambridge, Minnesota, 1978*

Lynn Butler,
*Amish Children
Coming Home
from School,
Pennsylvania*, 1989

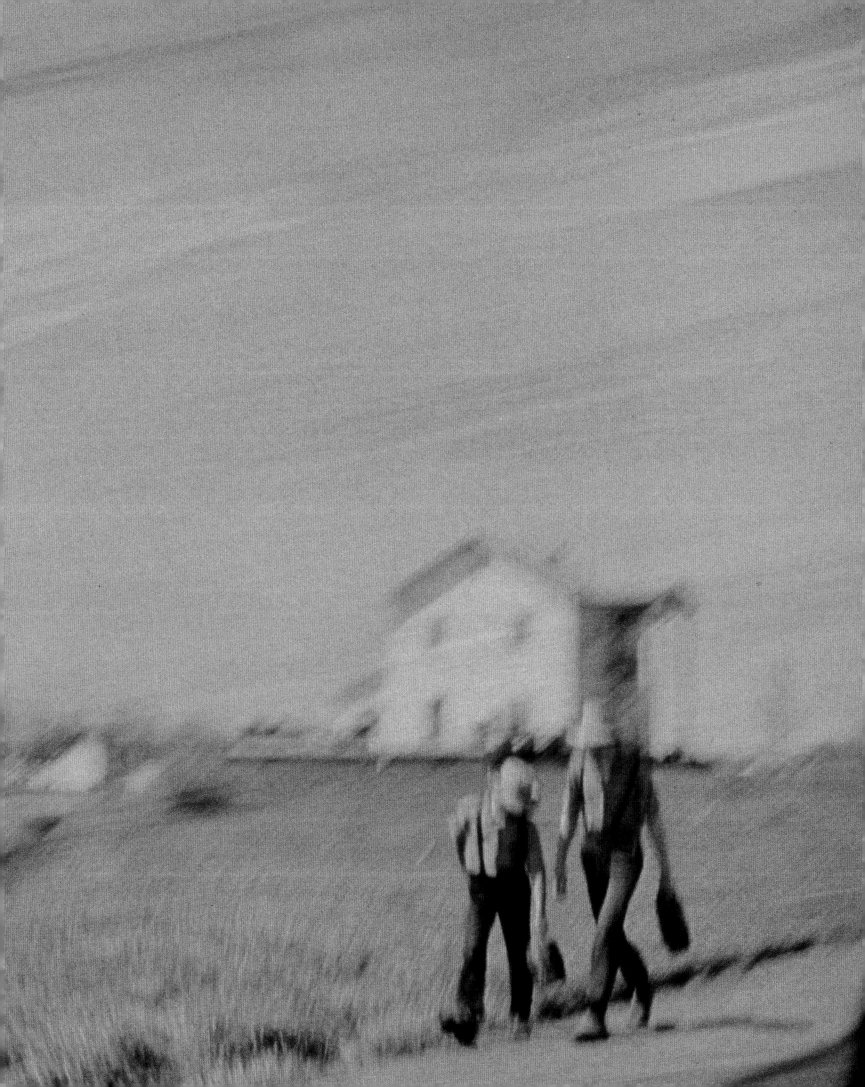

# HOME

## By Gary Indiana

*Home is where pathology meets entertainment.
Home is where children of Satan worshipers who
love too much and neurosurgeons who've
had sex changes turn up on "Geraldo." Home is
where you shouldn't leave without
your American Express card.*

Home is the police station. This is sometimes pictured as a one-story brick building, something like a school, with a tar parking lot and a flagpole in front. Home is also a gleaming office-tower penthouse overlooking a panorama of tissue-box buildings with tinted-glass facades, a telephone desk with a padded-leather chair, behind which a fifty-seven-year-old executive with gray hair and the face of a geriatric crustacean rubs his fingertips together, plotting his next evil acquisition. Home is a fuchsia designer gown worn by a vulpine over-the-hill brunette, her fingernails honed into talons, digging those fingernails into the naked back of a World Gym gigolo whose trapezius muscles tighten beneath her touch.

Home is a proscenium split-level living room where three late-middle-aged, one elderly woman disport themselves on a couch and two end chairs, exchanging lighthearted insults, and a kitchen in which they cheat on their diets. Home is a clinic where a witty receptionist banters with a handsome sad-sack pediatrician whose daughters are in fierce competition for sexual gratification. Home is a black family in a soigné Manhattan neighborhood where every day presents a fresh lesson in good behavior. Home consists of a dysfunctional suburban clan of cartoon characters.

At home there are white confidence men, holed up in fleabag hotel rooms, phoning hapless elderly black ladies with offers of a free color television. Thanks to an innovative call-tracing device not available in New York City, these white men are thwarted in their evil designs. At home, the telephone is more than just a lifeline: it is sex, rescue from addiction, a department store, a friend.

Home is the North, habitat of moose and squirrel, stomping ground of serial killers and slick city doctors with a lot to learn. Home is real people saying real things, rustic hunting lodges, moments of truth brought on by the exigencies of script closure, rich kids in high school discovering that money isn't everything. Home is a car with a sticker price below ten thousand dollars. Home is a series of normal Americans whose lives have been saved by airbags. Home is the hope of winning ten million dollars in a gigantic giveaway sweepstakes. Home is insurance that requires no physical exam.

At home there are dangerous lunatics living alone or with Mom who one day are "pushed too far" by the voices in their own brains, young men with vast arsenals of semi-automatic weapons in their utterly normal-looking houses, men who can't take it anymore and so come stalking into town, to the only place where large numbers of people still congregate, the fast-food restaurant. At home there are quiet, handsome dudes in their late twenties whose lives have been film loops of disappointment, men who've been deserted by mother, father, and other significant others, men whose "inner children" turn out to be flesh-eating incubi. Men with barrels of lye in their bedrooms, Black Sabbath on the CD, *The Exorcist* in the VCR.

At home there are cops. There are so many cops at home it's a miracle any crime gets committed there. There are cops staking out every drug dealer, cops on the trail of every thrill killer, cops breathing down the neck of every mafioso. At home there are cars chasing other cars endlessly up and down the streets of San Francisco, New York, Los Angeles, and Chicago.

Home is where money's the name of the game. Home is where they have to take you in when nobody else will. Home is where the heart is, and everybody's heart is big. Home is where wayward teens are chained to the radiator. Home is where battered women plot their escape. Home has to be investigated. Home is decor. Home is set design. Home is the refrigerator with the bloody palmprint on the door. Home is the head in the glass jar. Home is the heart in the deep-freeze. Home is the severed finger in the mayonnaise.

Home is a courtroom. Home is a district attorney and a defense attorney with sexual friction lighting up the courtroom. Home is a guilty defendant. Home is a technicality in the law that lets the guilty

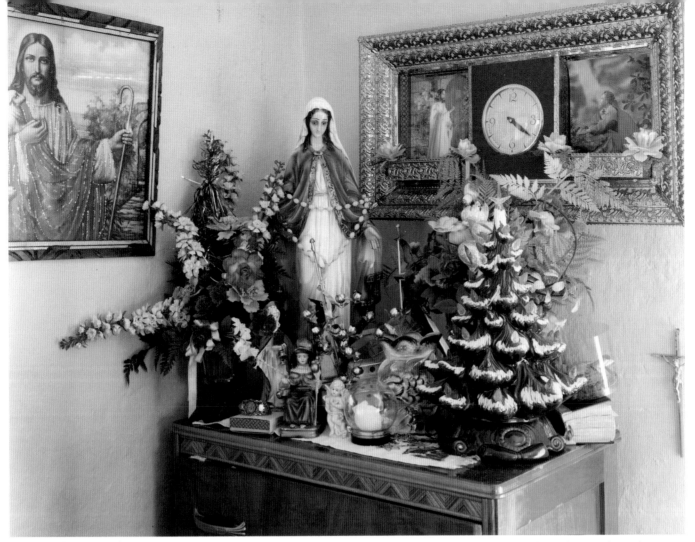

Alex Harris, *Genara Gurule's House, Rio Lucio, New Mexico*, 1985 *(above)*     Sandy Skoglund, *Gathering of Paradise*, 1991

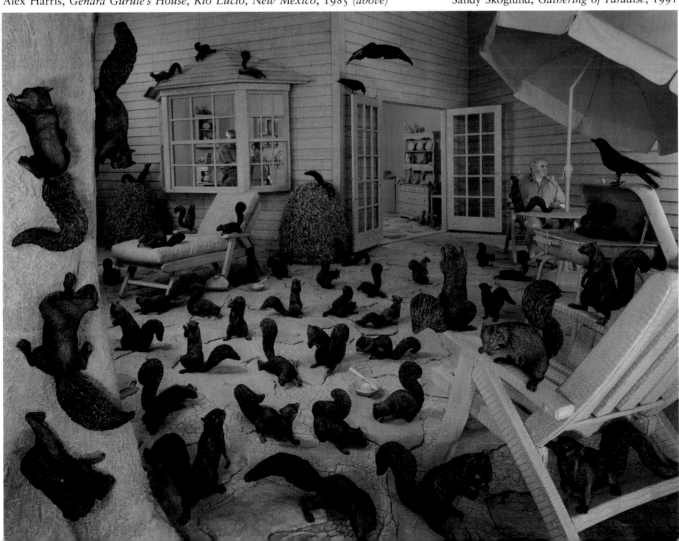

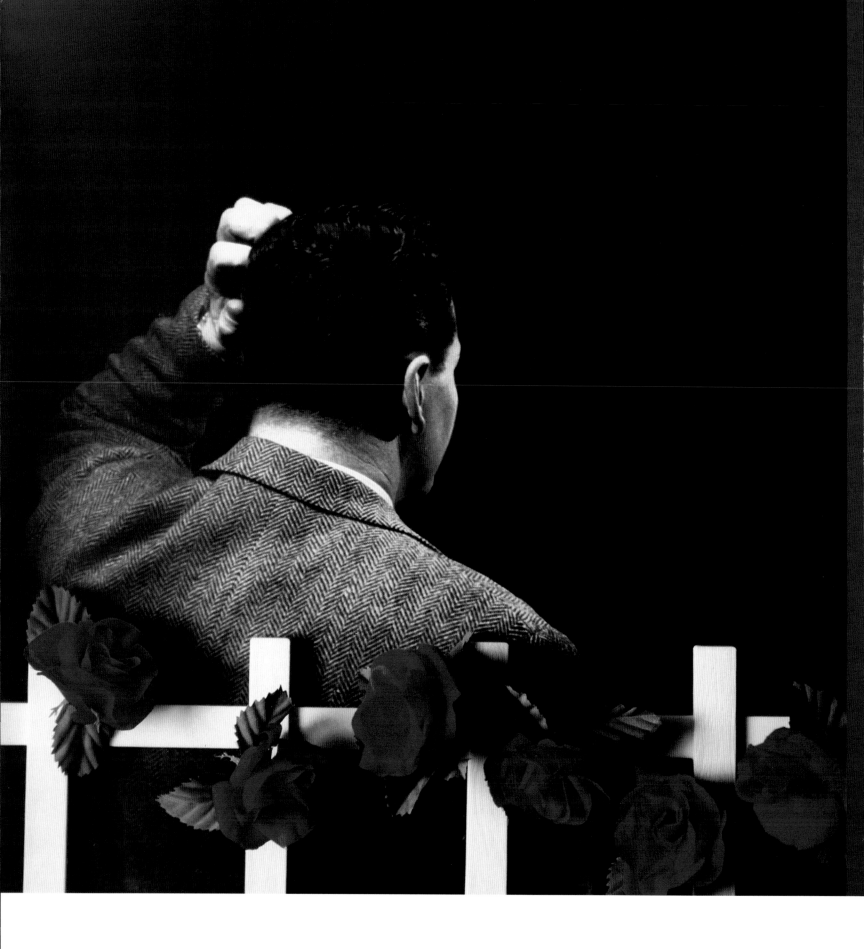

Home is a sleepy town in Anywhere, U.S.A.

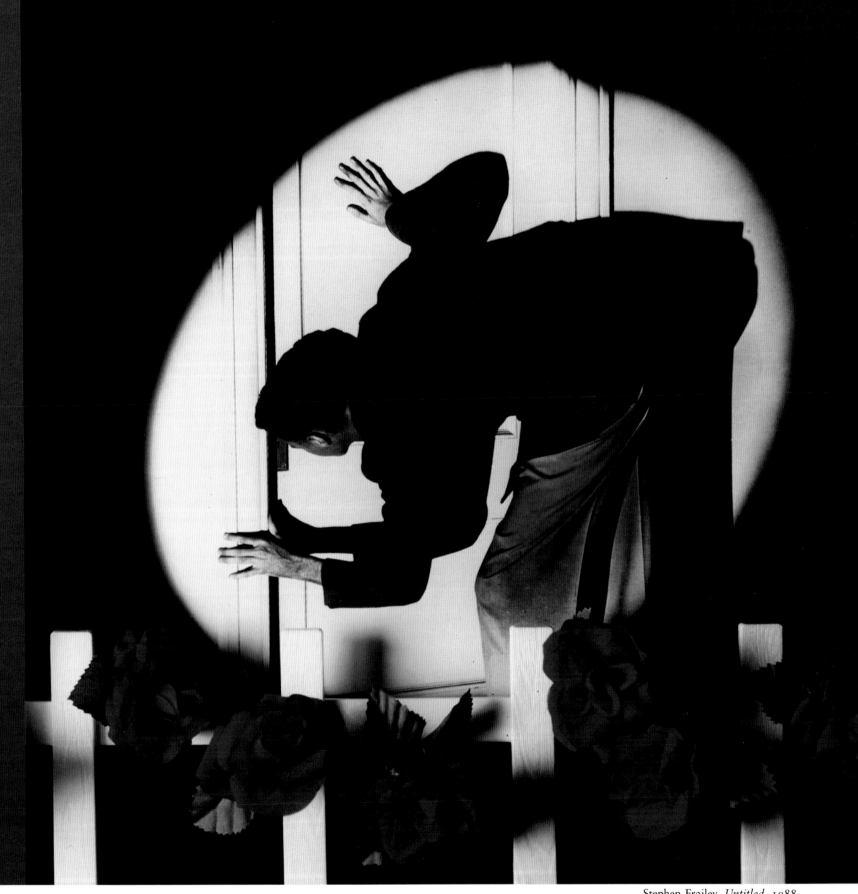

Stephen Frailey, *Untitled*, 1988

where something awful is about to happen.

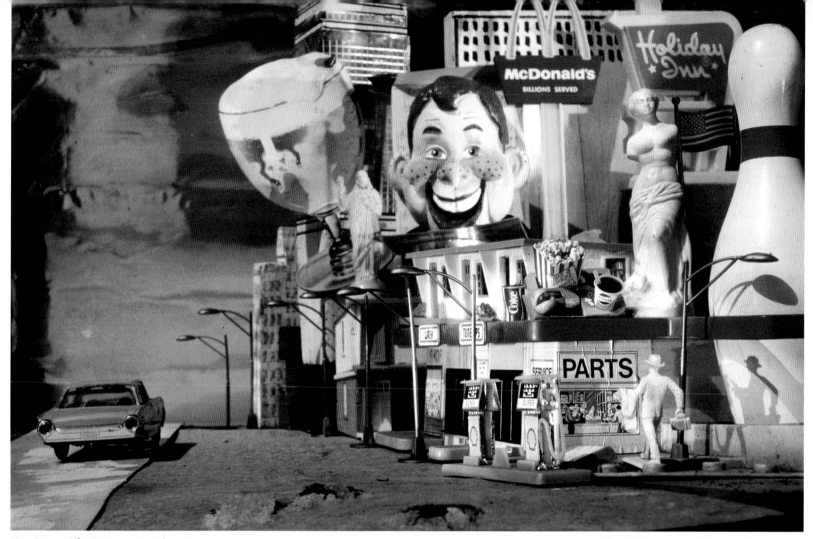

Ken Botto, *The Strip*, 1989 *(above)*

Jerald Frampton, *Burning House*, 1991

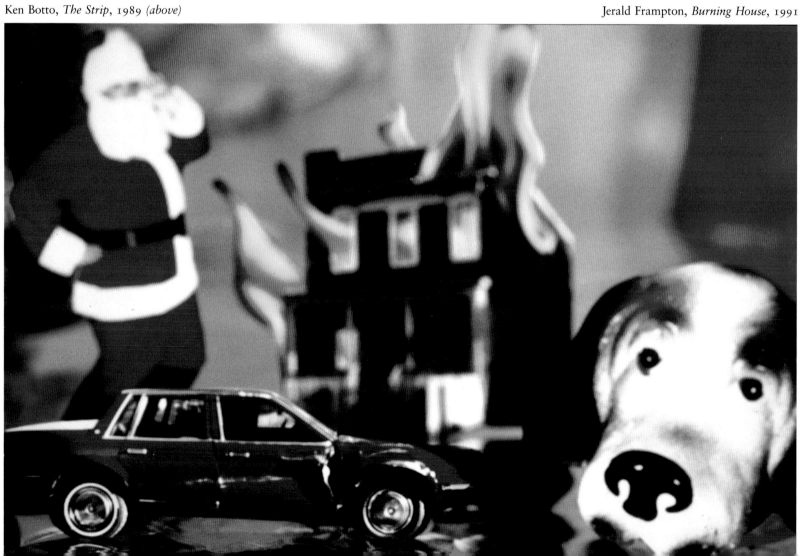

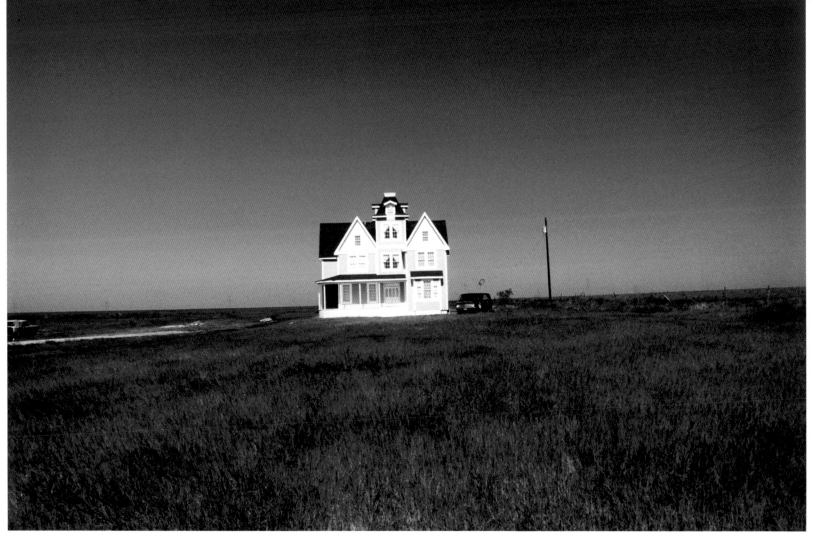

David Byrne, *Newly Painted House near Venus, Texas*, 1985 *(above)*

Philip-Lorca diCorcia, *Untitled*, 1988

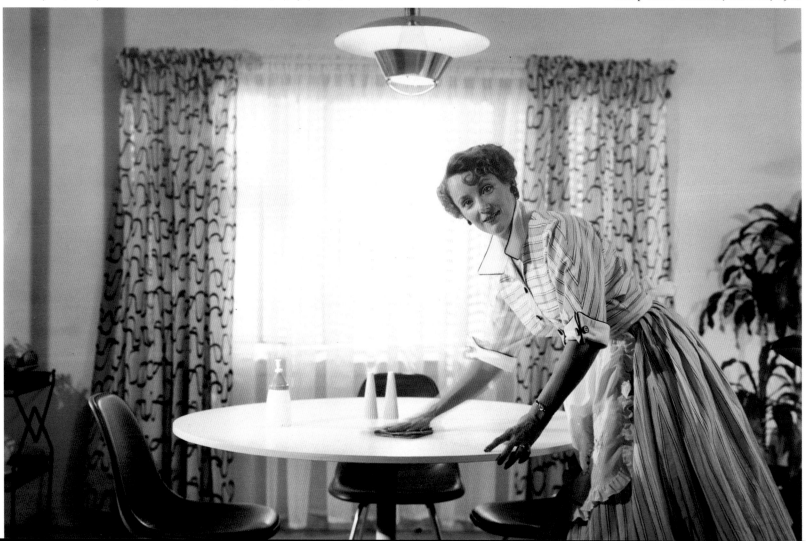

*Home is a car with a sticker
price below $10,000. Home is a series
of normal Americans whose lives have
been saved by airbags. Home is
the hope of winning $10 million in
a gigantic giveaway sweepstakes.*

go free while the innocent suffer. Home is taking the law into your own hands. Home is kill or be killed.

Home is leave ten thousand dollars with the guru or you'll never see your inner child again.

Home is a precinct station in Chicago. Home is a bald detective. Home is a sexy bald detective. Home is a sexy detective with hair. Home is a detective posing as a drug dealer. Home is a detective in drag. Home is a woman detective posing as a prostitute. Home is a woman detective posing as the victim of a serial killer. Home is a woman executive stalked by an insane rejected job applicant. Home is a network anchorwoman stalked by a deranged publicity seeker.

Home is where pathology meets entertainment. Home is where scam artists and murderous grandmothers roam the countryside in battered station wagons. Home is where chicks with dicks and the men who can't love them turn up on "Oprah." Home is where kids fathered by their grandfathers turn up on "Donahue." Home is where children of Satan worshipers who love too much and neurosurgeons who've had sex changes turn up on "Geraldo." Home is Barbara Bush for literacy. Home is the search for peace in Palestine. Home is where you shouldn't leave without your American Express card.

Home is a bankrupt city in the Southwest. Home is a stylish bungalow in Waikiki. Home is a fantasy island where all your dreams come true once you stop being such an asshole. Home is home finance. Home is the computer. Home is the lifestyles of the rich and famous. Home is homelessness. Home is a retirement village where lucky Americans bake their melanomas in the desert sun. Home is the "Bob Hope Golf Classic" and "Live from Wimbledon." Home is a giant beer bottle bursting from a Mayan pyramid and a giant bottle opener streaking through the rain forest. Home is a roll of toilet tissue occupying the seat beside you on the airplane. Home is a talking, garrulous toilet. Home is a train derailment, a flood, and a plane crash all within twenty-four hours. Home

is an unidentified sniper in the basement of the post office. Home is a grisly discovery in a basement in Philadelphia. Home is a three-card monte game with a tragic ending. Home is the domestication of apocalypse. Home is where everything happens and nothing makes any difference. Home is "Let's Make a Deal" on "The Wheel of Fortune." Home is "Jeopardy" in every sense of the word.

Home is an actor playing Hamlet who believes he is Hamlet. Home is Hamlet in a miniseries. Home is a sleepy town in Anywhere, U.S.A. where something awful is about to happen. Home is a saltbox on the prairie where a lonely man collects other people's viscera. Home is a priest with a terrible secret. Home is an insurance adjuster with a terrible secret. Home is the truck-stop waitress with odd designs on the husband of the local real-estate broker. Home is the high school coach with furtive yearnings for the entire swim team. Home is a basketball star on crack. Home is a quarterback on heroin. Home is a senator with his pockets stuffed with Mafia dollars. Home is a senator with a deadly secret. Home is a small town with a deadly secret. Home is an entire country with a deadly secret.

At home there are regular sightings of unidentified flying objects. At home, inexplicable transmissions on the local cable station presage an invasion of hostile aliens. Home is a starship winging through the hyperspace of Universal Studios with an intergalactic cast aboard. At home, small children are often the first to detect the presence of evil or people who have come back from the dead.

Home is a small child who has fallen down a deep well. Home is the rescue of whales, the humiliation of our enemies, the intersection of morality with sound medical practice. Home is an 800 number you can call to plant a tree that will save the environment. Home is the pulled-up bootstraps and triumph of the will. Home is the crotch of your Calvin Kleins, the firm rear end of your Guess jeans. *Hey, Joe, where you goin' with that gun in your hand?* Home is grandma knitting a sampler that says, "There's No Place Like Home."

Pretend           not to know           what you know

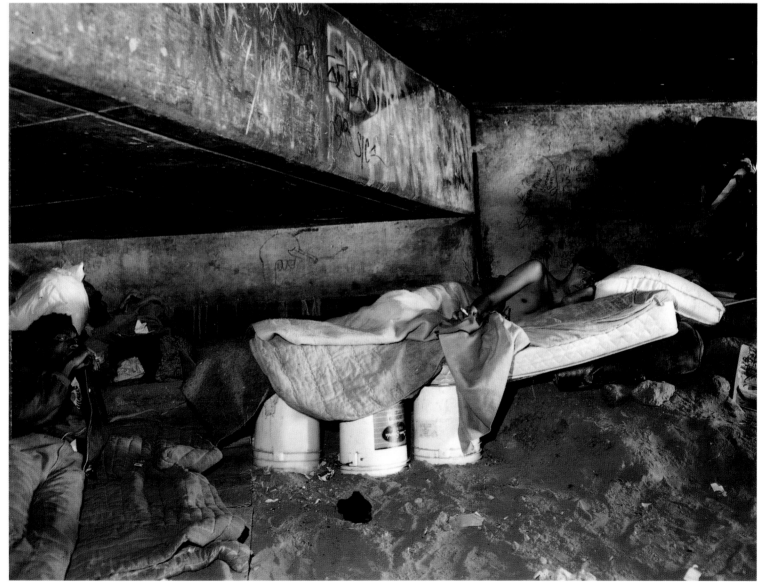

Jim Goldberg, Napoleon and Squirm at home underneath bridge, 1990

*Top*, Adrian Piper, *Pretend #2*, 1990

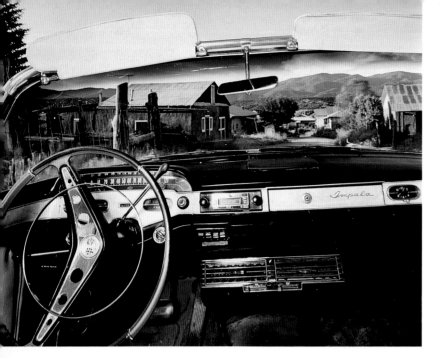

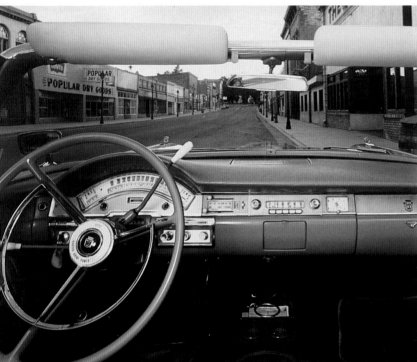

# S.O.P.

## By Richard Ford

Thoreau thought that places spoke, that they expressed themselves in a language "which all things and events speak without metaphor, which is copious and standard." And maybe we agree with him—some of us—so that when we read a book or see a photograph which contains, we think, a Sense of Place, we understand the writer or the picture-maker to have heard that language and somehow infused his objects with it so that we can know it, too. That, we would say, is his genius: he is the listener to a language only he can hear.

But I would say against Thoreau that places—mountains, street corners, skylines, riverbanks—do not speak, have no essences which can be "captured," heard. They are intransigent, mute, specific, and that is enough.

Language—spoken, written—advertises features we have not exactly known to exist in places. We might even say, if we are completely surprised, that language ascribes to places qualities they don't possess. Though in a connoisseur-ish way, we may finally believe that the language of a photograph has "found" a quality in a place; uncovered something new. But as with words joined in a phrase hoping for the new, such unions are often adventitious, made-up, and the photographer's genius lies in recognizing what he's done (i.e. imagined) with what he saw.

Likewise, if I look at a photograph taken on a street in Memphis—a rainy, blue-green day, the corner of a tall, brick house, a lawn, an oak, a magnolia in silhouette, a shining driveway pavement leading away—and I say, "Yes. This has that sense of place"—it is *my* sense I refer to. My sense feels as if an important event I'd somehow forgotten had occurred there, and this composition of images, colors had brought it flooding back. Something, some sense I didn't know I knew, has been awakened, like a reverie.

And my sense of place, of course, will not be yours, though we both know that street so well, both of us being Memphians. If we agree "this picture has a sense of place," we stress the similarities, neglecting the differences, relying on the adaptive, sympathetic capacities of another language to accommodate each other's views. We *need* to make it up between us, establish a feeling of community over the issue of a photograph we like and a pictured place which doesn't require us.

It's only human, of course, to think we recognize a place this way, some intimate part of it we believe we've known but not articulated. Life with others depends on such reconciliations, and we are likeable to the extent we are suggestible, that our imaginations can be engaged and that we connect.

Alex Harris, (top) *Looking North from Juan Dominguez's 1957 Chevrolet Impala, Chamisal;* (middle) *Looking West from Albert Gonzales' 1958 Ford Skyliner, Old Town, Las Vegas;* (bottom) *Looking East from Levi Lovato's 1972 Chevrolet Monte Carlo, Las Trampas; New Mexico,* July, 1987

*Opposite,* Charles Mason, *Pizza Hut,* Fairbanks, Alaska, 1987

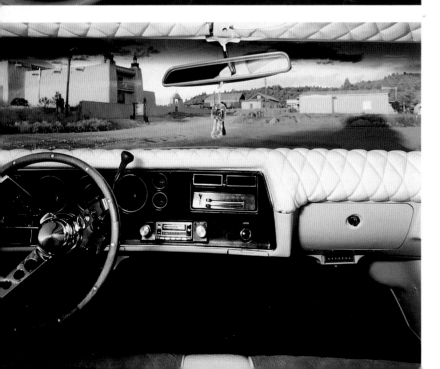

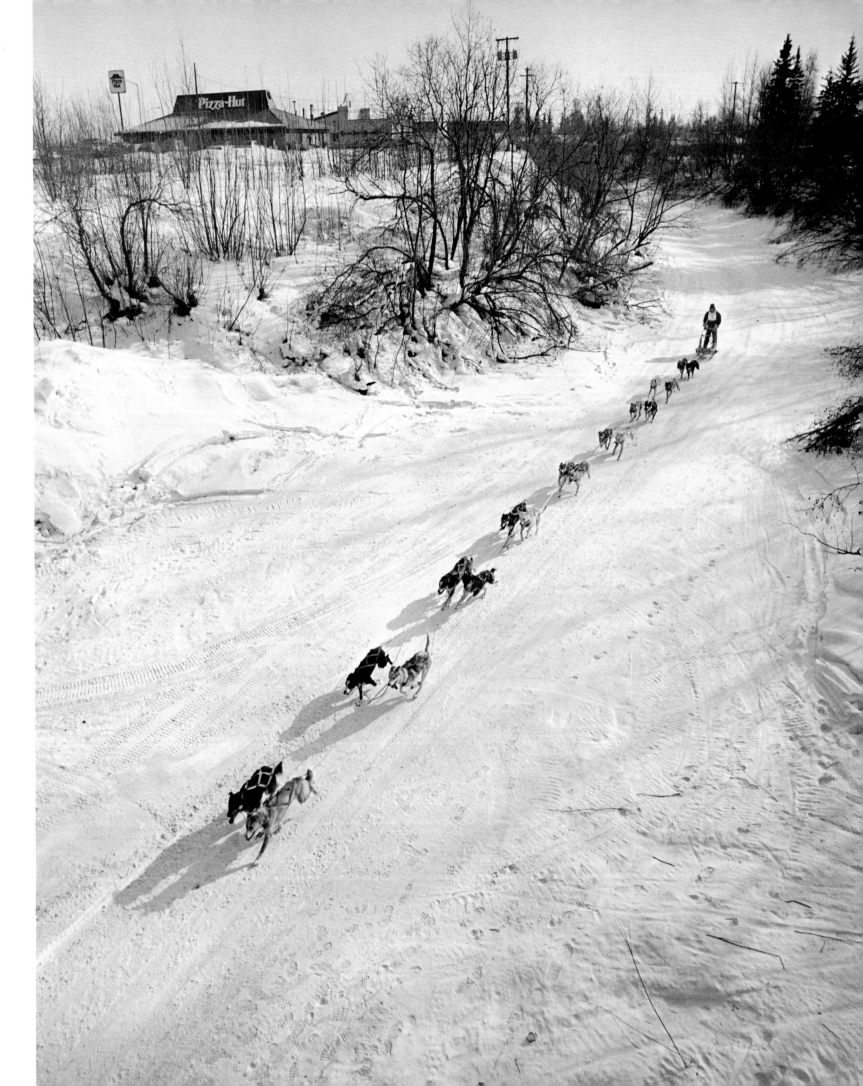

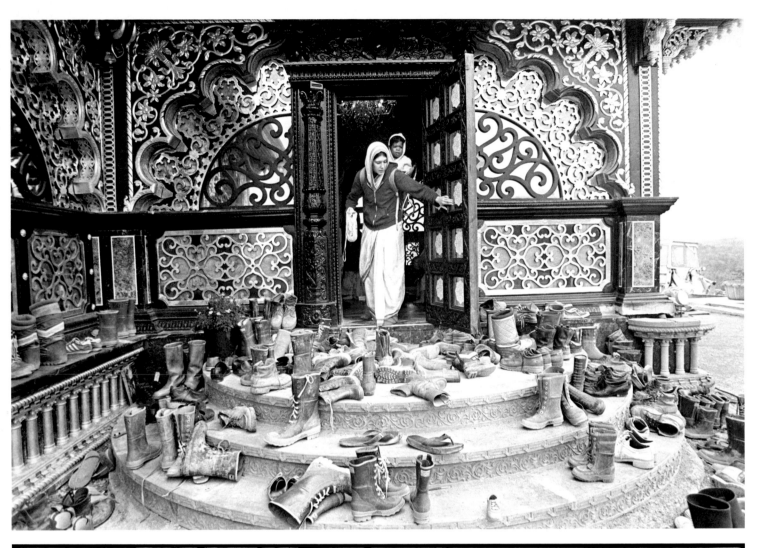

Ethan Hoffman,
*Krishna Temple,
West Virginia,*
1981

Marilyn Nance,
*Women's
Initiation
Ceremony
(Fodeima Enday
Sifuno), Queens,
New York,* 1986

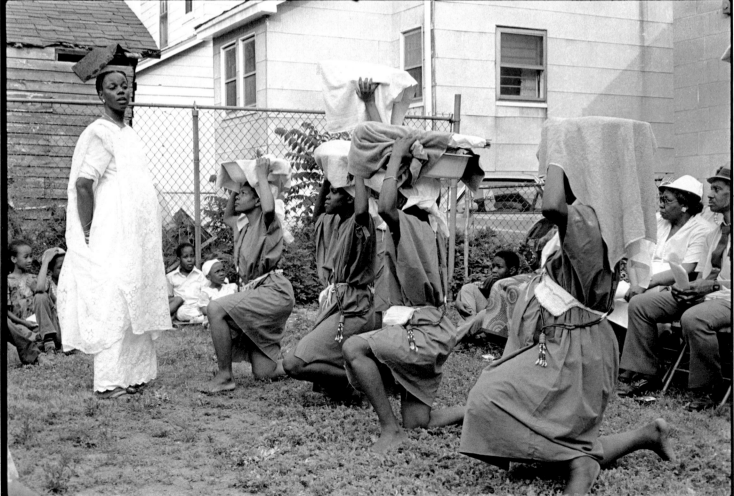

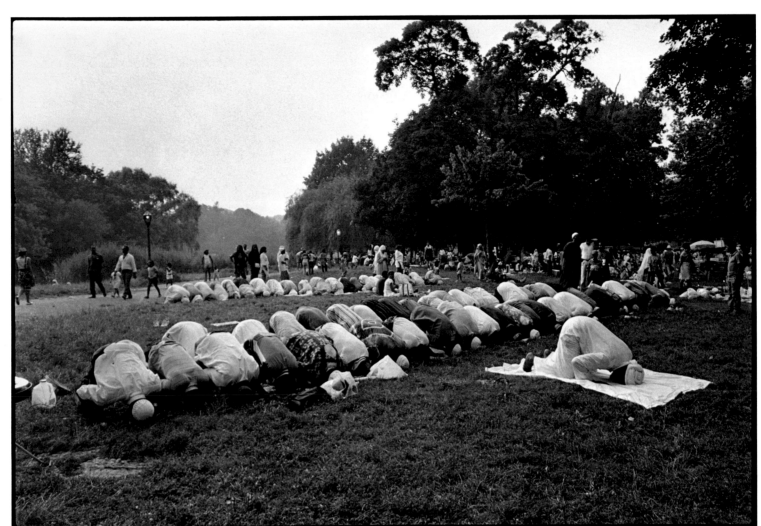

Marilyn Nance,
*Evening Prayers
in Prospect
Park, Brooklyn:
African
Islamic Mission
Black Power
Picnic,* 1987

Andy Levin,
*Organist
in Catholic
Church,
Verdigre,
Nebraska,*
1985

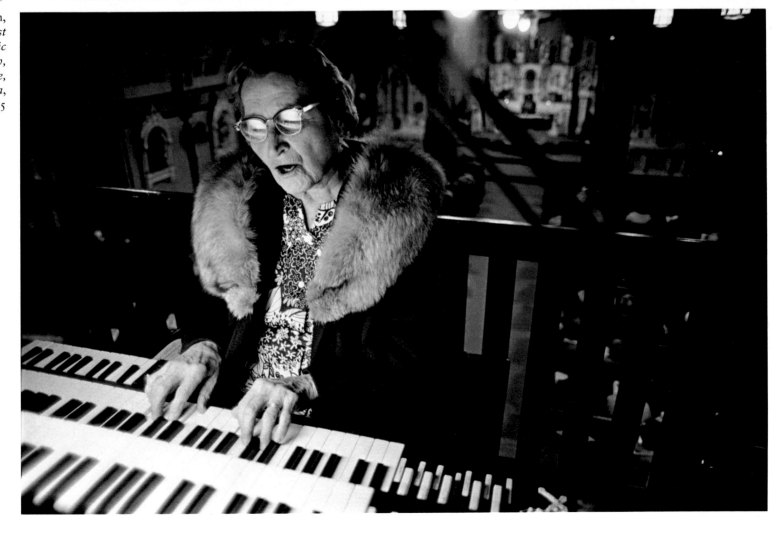

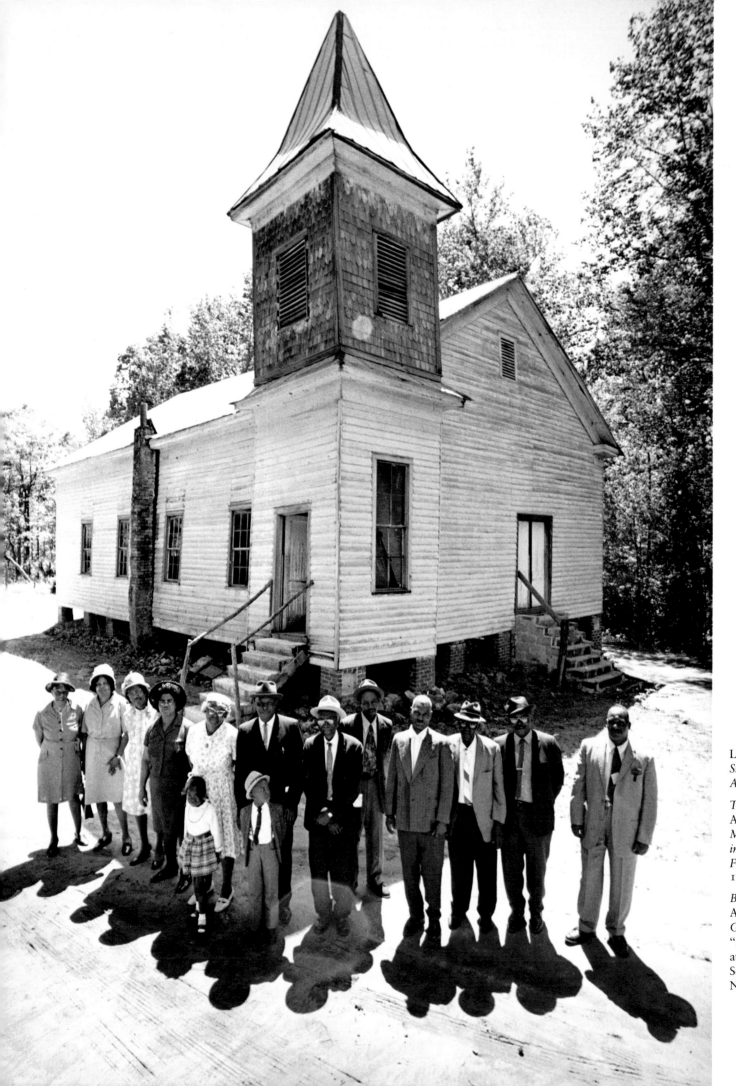

Leon Kuzmanoff,
*Snow Hill,
Alabama*, 1991

*Top right*,
Amy Arbus,
*Mingles Picnic
in Kissimmee,
Florida*,
1991

*Bottom right*,
Abigail Heyman,
*Garden Wedding*,
"Moonie" wedding
at Madison
Square Garden,
New York City, 1982

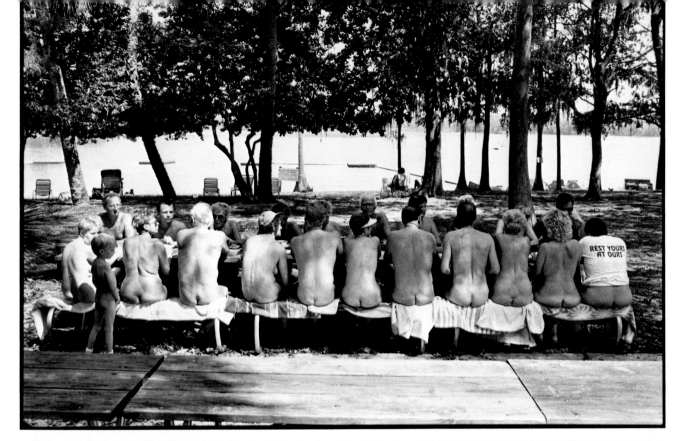

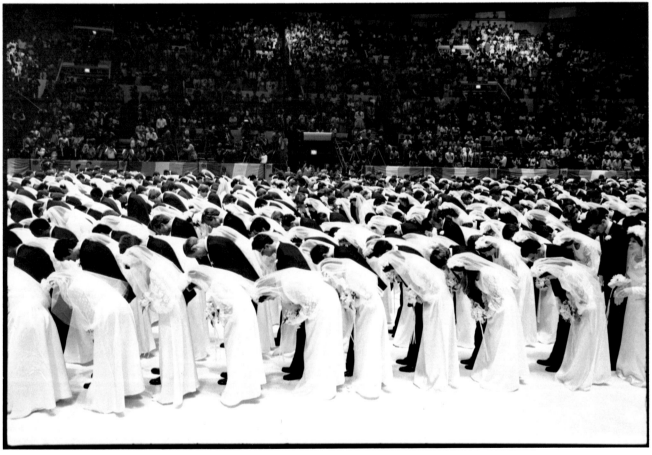

*Almost everybody in the world gets married—you know what I mean? In our town there aren't hardly any exceptions. Most everybody in the world climbs into their graves married. The First Act was called the Daily Life. This act is called Love and Marriage. There's another act coming after this: I reckon you can guess what that's about.*     Our Town, Act II

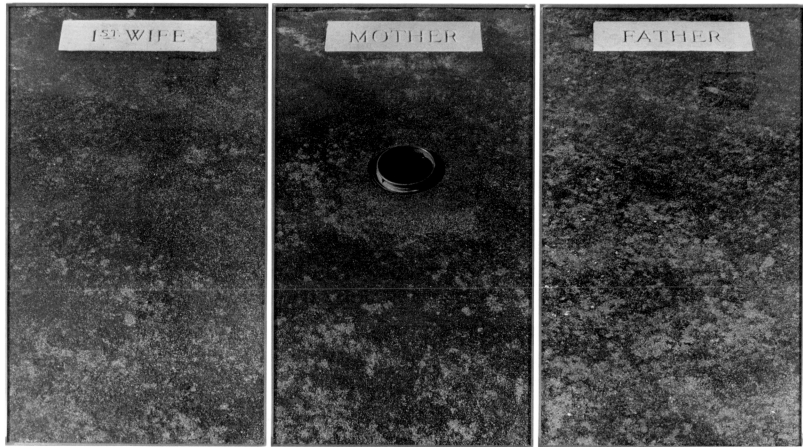

Sophie Calle,
*Untitled*, from
the series
"Graves," 1991

*Opposite*,
Andy Levin,
*Townspeople
of Verdigre,
Nebraska*, 1985

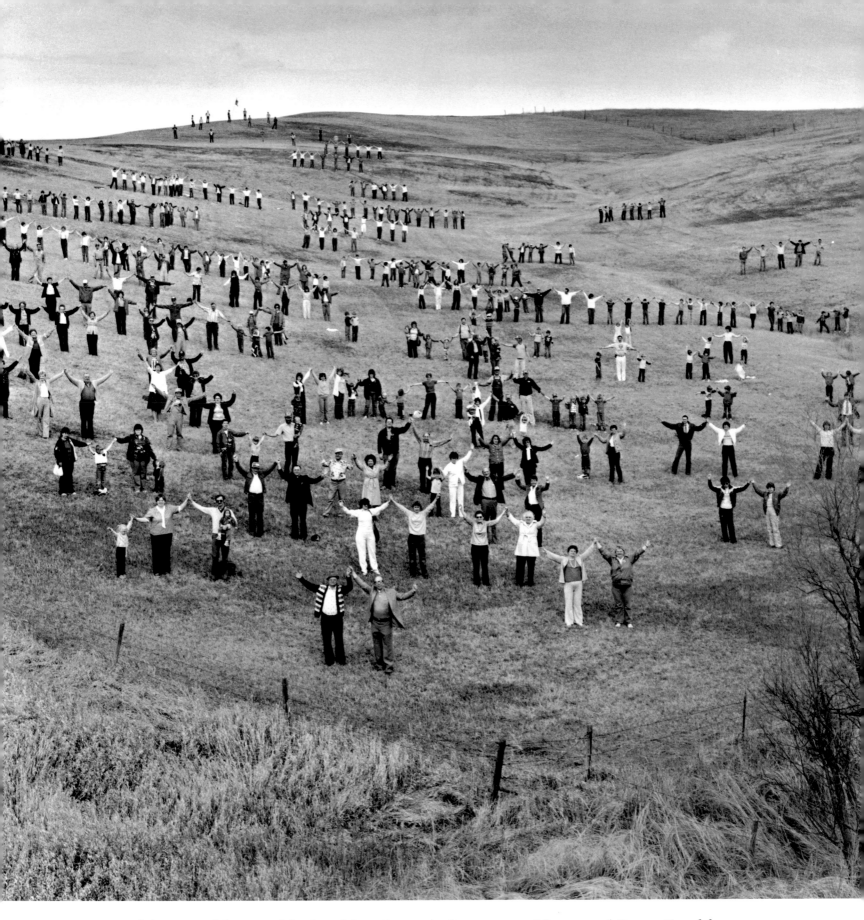

*Good-by, Good-by, world. Good-by, Grover's Corners . . . Mama and Papa. Good-by to clocks ticking . . . and Mama's sunflowers. And food and coffee. And new-ironed dresses and hot baths . . . and sleeping and waking up. Oh, earth, you're too wonderful for anybody to realize you.* EMILY WEBB, *Our Town,* Act III

# PEOPLE AND IDEAS

## POST-FRANCO MODERNISM

### By Judith Russi Kirshner

As if to affirm Spain's new political, social, and cultural role in the European Community, curators Denise Miller-Clark and John Kimmich Javier chose and classified 169 images by sixteen Spanish photographers for their ambitious survey, "Open Spain/España Abierta: Contemporary Documentary Photography in Spain," which opened at the Museum of Contemporary Photography at Columbia College, Chicago, in January.

The impressive accompanying catalog, published in Spanish and English, situates this tradition historically in learned essays by Lee Fontanella and Marie-Loup Sougez. Despite the political repression and cultural isolation of the country during Franco's regime, documentary photography appar-

ently survived and even flourished; its functional viability in transmitting a contemporary image of Spain is realized in this exhibition, which by extension bears witness to the political transformations and economic modernization of late twentieth-century Spain.

The exhibition, according to the catalog introduction, offers an unapologetic modernist vision "to capture the contradictions of a country in transition; the objective is to project a modern vision without sacrificing the intrinsic character that best embodies the Spanish enigma." On the one hand, there is the programmatic recording of technological and industrial progress—the new buildings and construction sites depicted in Alejandro Sosa Suarez's map-like

panorama of Seville and Manolo Laguillo's commissioned topography of Barcelona's Olympics. Both sites are ghostly, anonymous, and unpopulated by the workers ennobled by other photographers in the exhibition. On the other hand, many remarkable images emphasize the textures of ethnic and geographic diversity, multiple models of Spanish character: bullfights, laborers, and spectacles of fervent religious sects, whose traditions are dying only to be recalled through these documents. Contradictions (old-new, urban-rural) are articulated, but these come across as simple pairing, arraying the artists on either side of a false dichotomy, not unlike one that acknowledges the profound evil of Franco but not the colonialism and brutal conquests of the so-called Age of Discovery. These documents then, have been given a dual function: the projection of a nationalist vision and an affirmation of artistic value measured according to a canon of international modernism.

In this collection we see the street photography of Clemente Bernad, who records the odd juxtapositions, shadows, and fragments of social interaction. The blood and

Cristina Garcia Rodero, *Performing a Passion Play,* Riogordo, from the series, "Occult Spain," 1983

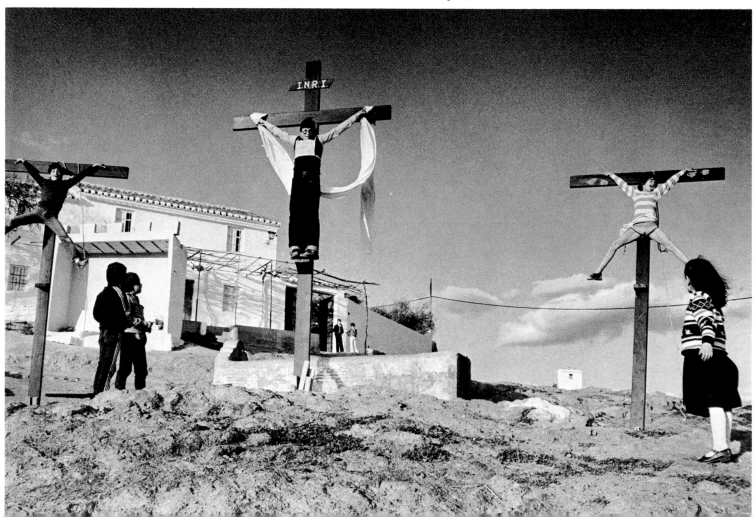

gore of the bullfight—as well as its glamour—are the subjects of Cristobal Hara's crystalline images: photographs of the ears and tails, the usually hidden, ragged edges of the spectacle, which are at once repulsive and fascinating. Koldo Chamorro's charcoal-black prints appear layered: individual portraits intersect with religious rituals and fiestas in traditionally artful images, which are moody, winning, and have a dated, albeit haunting aura. In Marta Povo's work, the sagging flesh of elderly, once elegant, women is displayed against and exposed by the slender, still-elegant art nouveau architecture of Catalonian spas. Spanish pop culture, kitsch accessories, but no trace of Pedro Almodóvar's irony and stylization are props for Xurxo Lobato. Manuel Sendon's color interiors featuring photographic murals of landscapes collage ideas about nature and artifice and, of all the work in this exhibition, are the least indebted to a documentary tradition. In a series of striking photographs by Juan Manuel Diaz Burgos, a young musician, a hunter, and a woman mourner are posed and illuminated like Velasquez's peasants, while the accompanying captions suggest comparisons with Diane Arbus and August Sander. Less romantic are Humberto Rivas's full-figure portraits silhouetted like paper dolls without benefit of context or sociological backdrop.

The most compelling works are those in the series "Occult Spain" by Cristina Garcia Rodero. The evocation of death, another persistent cultural theme, surfaces in religious spectacles, where children enact the Passion, or in a funeral procession where a pall bearer and the deceased look identical. Rodero's image of a young woman asleep, and dreaming, in the foreground of a threshing slope, is an unforgettable vision recalling the moods and paintings by Millet and the Douanier Rousseau.

Although the exhibition title celebrates openness and the curators have showcased photographers from every region of this large country, some stereotypical notions of Spanish idiosyncrasy fulfill rather than challenge our expectations. One senses a kind of associative frenzy: the wall labels offer numerous comparisons with modernist masters, with Alfred Stieglitz, Edward Steichen, and William Eggleston for aesthetic reinforcement in the accepted canon; with Charles Clifford, Lewis Baltz, August

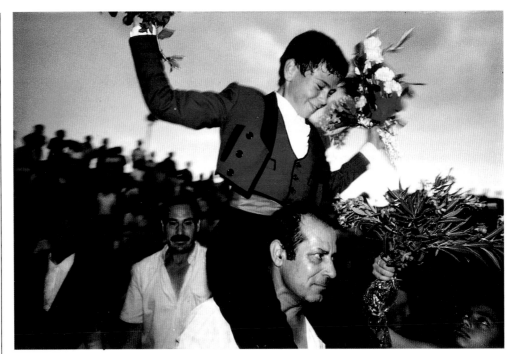

Cristobal Hara, *Untitled*, Madrid Area, 1987

*Many images almost become instant nostalgia—clones of earlier auras of old photographs, dated souvenirs, not contemporary evidence.*

Sander, and John Davies in the ranks of documentarians. In this way, many images are instantly veiled with a protective shield; they almost oxidize before our eyes and many images almost become instant nostalgia—clones of earlier auras of old photographs, dated souvenirs, not contemporary evidence.

A majority of the artists were mature in 1975 at Franco's death and surely were exposed to contemporary ideas from criticism and visual art. Yet one essayist, advancing an argument for a more complex layering of both a subjective, pictorial strain and authentically realist documentary work, never refers to contemporary cultural critiques or theories of representation. Instead, a historicist discussion—albeit an interesting one—of John Keats; Nicolas Boileau; eighteenth-century Spanish aesthetician Esteban de Arteaga; and Susan Sontag situates aesthetics and representation in classical terms of idealism and naturalism.

These comparisons mediate our response, ask us to assess achievement by external standards of aesthetic validation. So much contextualization tends to cloud rather than open our eyes, as if the art could not be trusted on its own to give visual evidence of the country, its diverse populations, its bizarrely intriguing spectacles and expansive, new urban landscapes. By locating a delayed modernity in post-Franco history, the exhibition unites politics and art to demonstrate the classic cliché—that art can flourish only under a truly democratic and republican regime.

Coinciding with and celebrating the quincentennial; Expo '92: "The Age of Discoveries 1492-1992" in Seville; Madrid's status as capital of Europe; and the Summer Olympics in Barcelona, this traveling exhibition was sponsored by a substantial list of governmental agencies, including the National Endowment for the Arts in Washington, D.C., the Embassy of Spain in Washington, D.C., the Illinois Arts Council, and Iberia Airlines. In the most exciting exhibitions, some art always manages to escape the boundaries of the organizing principles to confront us on its own terms. Here, the boldest images, obliged to serve too many masters, still absorb us as documents of difference and exoticism; they remain while the sweeping generalities fade away.

The exhibition will travel throughout the United States, Europe, and Latin America.

# DELAYED

## By John Waters

*Airports*, photographs by Peter Fischli and David Weiss. Published by Edition Patrick Frey and IVAM, 1990.

*Airports*, the numbing, beautiful, and finally hilarious photo-book by Swiss artists Peter Fischli and David Weiss, confused me at first. I was browsing a Zurich bookshop while on an endless promotional tour: the over-sized, prominently displayed, expensive coffee-table book with that generic title invited a quick peek inside. Seeing mediocre, glossy, postcard-style photos of exteriors of nondescript airports, presented page after page in elegant binding with no text, only produced a shrug as I moved on to the safer ground of the esoteric postcard rack. But I kept coming back and flipping through *Airports* again and again. "What the hell is this?" I thought. "Eighty dollars?! For dull outtakes from an in-flight magazine? What will they think of next?" I found myself grumbling, just like the dullards who panicked when they first saw paint dripping or soup cans.

Then I started laughing. I was finally surprised by something. Even outraged. What an exhilarating feeling to realize that purposeful mediocrity is the only subtle way left to be new. Obsession soon followed. I whipped out my American Express card and gleefully signed the dotted line and my travels have never been the same since. Every time I look out an airplane window in boredom, frustration, and exhaustion, I see a mediocre still life even duller, more stupid, and less remarkable than Fischli-Weiss's. And I'm convinced that I've glimpsed a new kind of 1990s beauty, over and above the banality of pop or the exasperation of minimalism into a shockingly tedious, fair-to-middling, nothing-to-write-home-about, new kind of masterpiece.

I want to know who first said *Airports* was good. It's hard to visualize a publisher sitting at his desk debating the merits of these astoundingly inert still lifes without being familiar with the artists' past work (rubberized dog dishes, self-destructing kinetic installations on film, and scarily familiar tourist sights so overly photographed—Stonehenge, the Eiffel Tower, the Pyramids of Giza—that they appear to be calendar pin-ups when snapped once again by these two pranksters). "Let's see," our editor might think, "here's a shot possibly taken from a stalled courtesy van across the street from a static airport, too far away for any detail and framed so the foreground is filled with empty asphalt marred accidently and undistinguishedly by a small wad of trash. "Get in here!" he screams to his startled staff, "I've seen the future of photography! We *have* to publish this book and I don't care what it costs!" The emperor's new clothes? Don't ask me, I never understood the moral of that story anyway. If the emperor walked down the street naked and everybody told him how good he looked, who am I to spoil the cutting edge of fashion? *Airports* will inspire the "But he has nothing on!" response from the internationally humor-impaired, but I applaud these new "emperors," Fischli and Weiss, and salute their lethal passivity with glee.

What's really bewildering is that some of the photos are almost pretty. A rainbow shockingly appears in an oil slick mixed with rainwater from a recent thunderstorm at an unidentified airport in one of the untitled, unindexed portraits. But a closer inspection reveals only the corporate airline logo on the tail of the plane reflecting back a spectrum of color at the disappointed viewer. Twilight is a relief from the hazy daytime views of uneventful, unglamorous world travel, but detail such as a Mariott truck deadens any pleasure one could get from a beautifully photographed sky. Night shots are at least dramatically lit by airport industrial lighting, but how pretty can a catering truck be at any time of day? Foreign skylines, lush greenery, even a romantic sunset are ruined by these crazed photographers who go about their task as if hired by a postcard company that they hated with psychotic understated fury. Looking at their work has the appeal of being trapped in the rear of the tourist section of a stalled jet in summertime as the stewardess announces in three languages that she apologizes for the air conditioner's malfunction but not to worry, "We are number eighteen in line for takeoff."

The very worst photos are of course the wittiest but need to be surrounded by

*The very worst photos
are of course the wittiest
but need to be surrounded by
the merely second-rate
to be appreciated in the
proper perspective.*

the merely second-rate to be appreciated in the proper perspective. An empty passenger jet undramatically parked in an unlit hanger is just as dull as it sounds. And a perfectly centered medium shot of a windowless Lufthansa cargo plane may force us to realize we're not much better off here than the packages inside (there's nothing to look at even if they *could* see), but it still takes an especially desensitized eye to savor this run-of-the-mill vision. The most radically ordinary images have no planes at all, just abandoned airport equipment, security vehicles rushing to nowhere, empty cargo trucks, and airport personnel—never more nameless—blurred in the jet pollution, silhouetted by their uncaring cities that could be anywhere in the world.

My favorite photograph in the book is the most maddeningly mediocre. A parked Federal Express plane sits in an airport with portable debarkation steps at its door. No people. Absolutely nothing is happening. "Next Day Delivery" never looked so unrushed. A bus used to take passengers to the gate is heavily featured as it drives by, empty except for the unseen driver. We know it can't stop; packages don't have friends to meet them at customs. It's a bad advertising shot that would be eliminated on the first editing pass from any corporate business catalog. There is no activity, no drama of any kind. It is impossible to see any reason ever to reproduce this photo in any form. Ultimate mediocrity has finally been achieved.

How much could it cost to purchase this picture? What could it actually be like to have it beautifully framed hanging over the fireplace in your living room? I try to imagine Fischli and Weiss's mood when they finally captured this masterwork. Were they exhausted after weeks of international travel to drab airports, or did they flippantly do this book all in one week, using every picture they took, snapping away without even bothering to look through the lens? Had they just ritualistically chanted the magic airport words, "jetway," "carousel number three," or "unlikely event of a water landing," and laughed conspiratorially when they stumbled upon this vision of wearying tedium? Or were they giddy from experiencing the pinnacle of air travel—the moment when all the stewardesses in exact choreographed unison point their index fingers twice, I repeat twice, at the nearest emergency exit with that incredibly embarrassed, bored, sexually humiliated expression? Is this photo worth a thousand words, as they say? Hardly. A hundred? Doubtful. One? Yes. Art.

## CONTRIBUTORS

SHELBY LEE ADAMS is head of the photography program at Salem State College, in Massachusetts. He has been photographing in Appalachia for over seventeen years.

DAVID BYRNE, best known as the lead singer and songwriter for the Talking Heads, co-wrote the film *True Stories*. A Talking Heads anthology, "Popular Favorites: Sand in the Vaseline," is tentatively scheduled for release in September of 1992. Last summer Byrne's photographs appeared in "Beyond Japan: A Photo Theater," at the Barbican Art Gallery in London.

RICHARD FORD is a novelist. His latest novel, *Wildlife*, is available from Vintage Books.

GARY INDIANA's most recent work is a play, *Roy Cohn*, part of a double portrait performed by Ron Vawter, *Roy Cohn/Jack Smith*.

JUDITH RUSSI KIRSHNER is a critic for *Artforum* and Director of the School of Art and Design at the University of Illinois at Chicago.

NAN RICHARDSON is a writer and editor, as well as a partner in Umbra Editions, a packager of visual books.

MICHELE WALLACE is Associate Professor of English in Women's Studies at City College at the CUNY Graduate Center. She is the author of *Black Macho and the Myth of the Superwoman*, reprinted by Verso/Routledge in 1991, and *Invisibility Blues* (Verso/Routledge, 1991).

JOHN WATERS is the director of *Pink Flamingos*, *Hairspray*, *Cry Baby*, and other films. He is also the author of *Shock Value*, *Crackpot*, and *Trash Trio*. He is currently at work on a new film.

MARIANNE WIGGINS was born in Lancaster, Pennsylvania, in 1947. She has lived in Paris, Brussels, Rome, New York, and London, and now lives in Washington, D.C. She is the author of *John Dollar*, a novel, and *Bet They'll Miss Us When We're Gone*, a collection of stories, among other books. She is at work on a new novel.

## ACKNOWLEDGMENTS

We would like to thank the following people for their assistance and advice: Sarah Caplan, Todo Mundo; Peter C. Jones; Meryl Levin, the Picture Project; and Mark Marvel.

We would also like to thank all of the photographers, galleries, and photo agencies who spread the word and helped make "Our Town" possible.

## CREDITS

NOTE: Unless otherwise noted, all works are courtesy of, and copyright by, the artists.
Front cover: photograph by Gregory Crewdson; p. 2 photograph by Skeet McAuley, detail of mixed-media installation; p. 11 photograph by Joel Sternfeld, reproduction courtesy of Pace/MacGill Gallery, New York; p. 15 photograph by Joel Sternfeld, reproduction courtesy of Pace/MacGill Gallery, New York; p. 16 photograph by Susan Meiselas, courtesy of Magnum Photos, New York; p. 17 photograph by Patrick Nagatani, courtesy of Jayne H. Baum Gallery, New York; p. 20 (top) photograph by Joel Sternfeld, reproduction courtesy of Pace/MacGill Gallery, New York; p. 22 photograph by Patrick Zachman, courtesy of Magnum Photos, New York; p. 25 photograph by Paul Strand, courtesy of the Paul Strand Archives, Millerton, New York; p. 26 photograph by O. Winston Link, courtesy of Robert Burge/20th Century Photographs, Ltd.; p. 38 photograph by Mary Ellen Mark, courtesy of the Mary Ellen Mark Library, New York; p. 39 photograph by Clarissa Sligh, Van Dyke Brown print; p. 57 (bottom) photograph by Sandy Skoglund, 50×70" Cibachrome of installation, courtesy of P.P.O.W., New York; p. 63 (top) photograph by Adrian Piper, courtesy of John Weber Gallery, New York; p. 66 (top) photograph by Ethan Hoffman/Picture Project; p. 70 photograph by Sophie Calle, courtesy of Pat Hearn Gallery, New York.

1991, toned gelatin silver print, 5.5 x 6.5 in.

# Tulips
*Twenty-One Photographs*

A limited edition portfolio
of tulips by

## Dennis Letbetter

*Published & distributed by*

**Editions Michel Eyquem**
1256 Masonic Avenue
San Francisco, CA. 94117

**Between Home and Heaven**

Contemporary American Landscape Photography

*Essays by Merry Foresta, Stephen Jay Gould, and Karal Ann Marling*

*Cloth: 0-8263- 1363-9  $50.00*
*Paper: 0-8263- 1364-7  $35.00*

*At bookstores, or call (505) 277-4810*
*FAX 1-800-622-8667*

UNIVERSITY OF NEW MEXICO PRESS
ALBUQUERQUE, NEW MEXICO 87131-1591

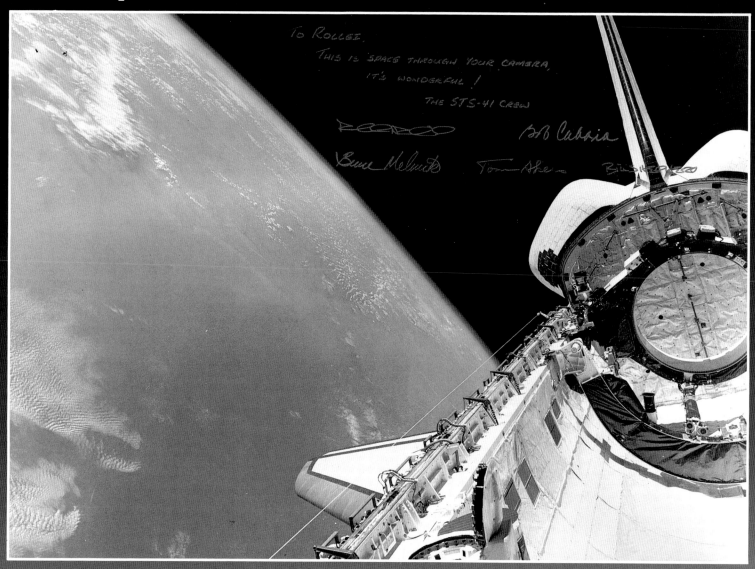

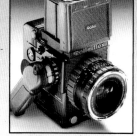

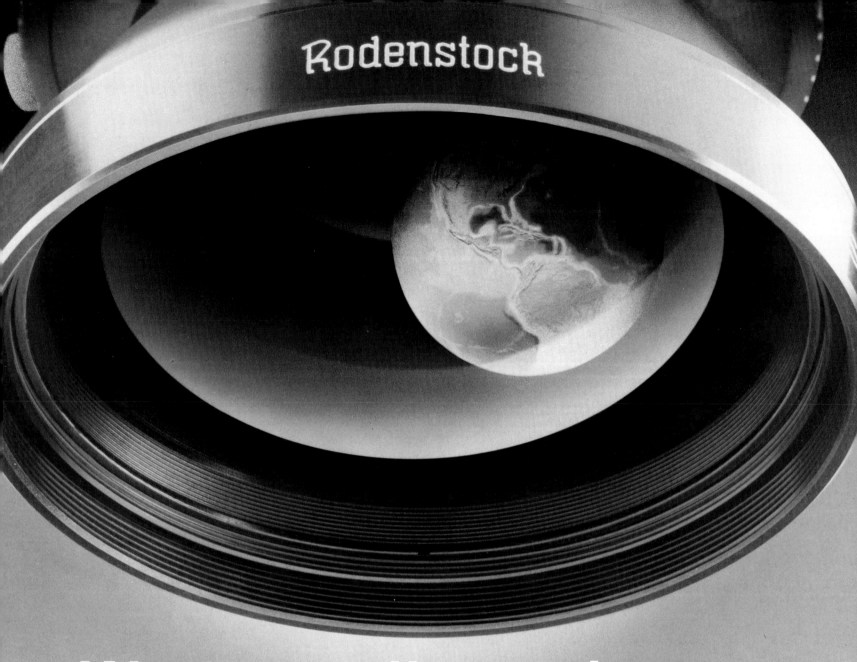

Rodenstock

# We give you the most ways to view the world.

In all the world, Rodenstock has the largest selection of large format and enlarging lenses. This system gives you the greatest chance to solve *any* photographic problem—without sacrificing any quality. Because overall, Rodenstock lenses have superior speed, edge-to-edge sharpness, coverage and absolute color fidelity from lens to lens. And our technical support to you is second to none.

**What makes Rodenstock, Rodenstock.**

For over 110 years, Rodenstock's high German standards have remained intact: in the design, the manufacturing, and in the measurement techniques/equipment that ensure you superior quality lenses. All applicable scientific data from our Research & Development staff, unique experiences in laser-optics

electronics and NASA space programs go into every Rodenstock lens.

**Unduplicated views.**

We offer uniquely designed lenses which enable you to see the world in special ways. Our Macro Sironar, for example, is 2 lenses in 1: it adjusts from $\frac{1}{3}$ lifesize to lifesize to 3 times lifesize. Imagon is continuously variable from very, very soft to very, very sharp. It is *the* soft focus lens.

**You're already looking at Rodenstock.**

No single lens can handle every situation. Not yet, anyway. And lenses of questionable quality can ruin your reputation. View your world through Rodenstock. 2 out of every 3 process cameras use our lenses, so chances are you're viewing the reproduced world through Rodenstock already.

**HP Marketing Corp.**
16 Chapin Rd., Pine Brook, NJ 07058, 201/808-9010

# Rodenstock
**The world's greatest depth of quality.**

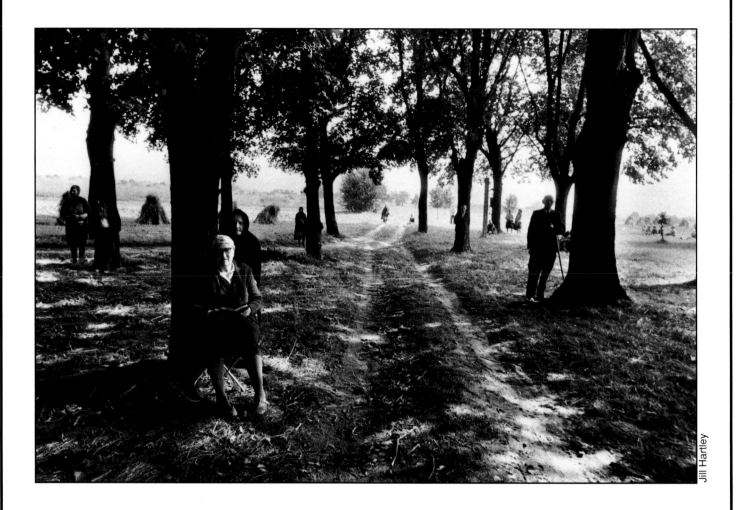